A–Z

OF

EDINBURGH

PLACES - PEOPLE - HISTORY

Lisa Sibbald

AMBERLEY

First published 2018

Amberley Publishing
The Hill, Stroud, Gloucestershire, GL5 4EP
www.amberley-books.com

Copyright © Lisa Sibbald, 2018

The right of Lisa Sibbald to be identified as
the Author of this work has been asserted in
accordance with the Copyrights, Designs and
Patents Act 1988.

ISBN 978 1 4456 7975 4 (print)
ISBN 978 1 4456 7976 1 (ebook)

British Library Cataloguing in Publication Data.
A catalogue record for this book is available
from the British Library.

Origination by Amberley Publishing.
Printed in Great Britain.

Contents

Introduction

Edinburgh is, and always has been, a city of contrasts. Rich and poor, light and dark, good and bad – they have existed side by side since Edinburgh's first beginnings. The city exists on two levels, not just metaphorically, but physically, as you can see if you stand on South Bridge or George IV Bridge and look down onto the streets below. Nowadays, we can add the ancient and the modern to those contrasts. A quote from author James Grant in the 1880s sums up Edinburgh's atmosphere perfectly: 'In Edinburgh every step is historical; the memories of a remote and romantic past confront us at every turn and corner, and on every side arise the shades of the dead.'

Yet, while history is all around, Edinburgh remains a centre of innovation and still produces pioneers, scientists and doctors, as she has done for centuries, who are at the forefront of their respective fields. This book looks at some of the people and places that through the years have combined to make Edinburgh the fascinating, inspiring and unique city that it is.

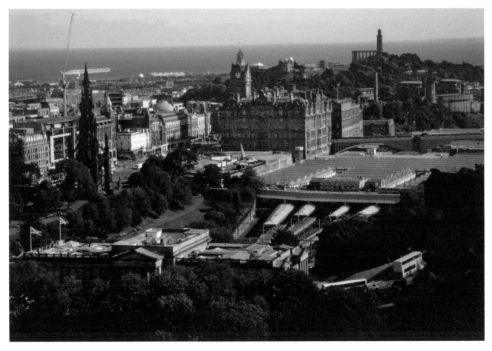

Looking north-east from Edinburgh Castle to the Firth of Forth.

A

Ann Street

Probably one of the prettiest streets in Edinburgh, and certainly one of the most expensive, Ann Street is a street of Georgian houses in the Stockbridge area of the city. It was named after Ann Edgar, the wife of artist Henry Raeburn, who drew designs for the street along with architect James Milne in 1817.

Ann Street, where many of the properties are Category A listed, is unusual among Georgian streets as it has large front gardens.

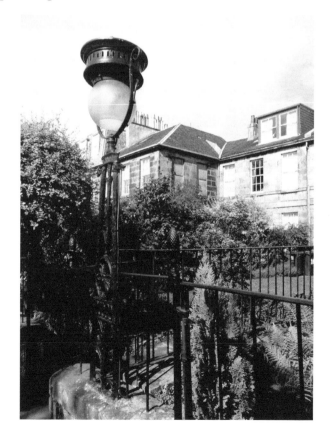

The Georgian elegance of Ann Street.

Arthur's Seat

Arthur's Seat, in Holyrood Park, is an 822-foot-high (251-metre) hill with wonderful panoramic views from the summit. Arthur's Seat has a very distinct shape of a crouching lion, and the summit is popularly known as the Lion's Head.

The origin of the name is uncertain, with one possibility being that it is from the Gaelic *Ard-na-Said*, meaning 'Height of the Arrows'.

Arthur's Seat is an ancient, long extinct volcano that erupted around 350 million years ago, sending rivers of lava over the surrounding area. Traces of ancient civilisation can still be seen, such as broad terraces that may have started out as Bronze Age fields, and remains of hill forts. Standing high above the surrounding ground, the summit of Arthur's Seat was a perfect spot for defence as well as for lighting warning beacons.

There are various routes to the summit, ranging from fairly easy to much steeper and more strenuous, but all require sensible footwear as the walking surface is uneven and can be slippery. At the summit, there is a topograph that will help you identify the various other hills and landmarks you can see from Arthur's Seat.

A local legend going back hundreds of years said that if young women washed their face in the dew on May Day it would keep them youthful and beautiful. Today a service of Christian worship is held at the summit at daybreak on May Day, when people also still gather to wash their faces in the dew.

Arthur's Seat in Holyrood Park.

Barrace Steps

This set of steps isn't anything special in itself, but the name reflects an interesting history in the area. The Barrace was an ancient tilting ground, first laid out by the garrison who held Edinburgh Castle for Edward III from 1334 to 1341. Combats took place on the narrow area beside the road to St Cuthbert's. The Barrace Steps, which run from Castle Terrace to King's Stables Road, were named in 1983 to commemorate this.

Barrace Steps from King's Stables Road.

James Miranda Barry

James Miranda Barry, born in Ireland in 1789, studied medicine at the University of Edinburgh, graduating MD in 1812. In 1813 Barry gained membership of the Royal College of Surgeons in London. Dr Barry then went on to have a very successful career as a military surgeon in the British Army, serving in many parts of the British Empire and rising to the rank of inspector general incharge of military hospitals in Canada.

What makes Dr Barry's story interesting and significant is that 'he' was in fact the first British woman to gain a medical qualification.

Born Margaret Ann Bulkley, she was determined to become a doctor at a time when women were not admitted to medical school, so she created a new identity for herself as James Miranda Barry and travelled from Ireland to Edinburgh to study at the medical school. Throughout university and her working career, Dr Barry was accepted as being a man and it was only after her death from dysentery on 25 July 1865 that it was discovered that Dr Barry was in fact a woman.

Bay City Rollers

One of the biggest selling and most popular music groups of the early 1970s came from Edinburgh.

The Bay City Rollers were first formed by manager Tam Paton in 1968, and by 1974 'Rollermania' had gripped the United Kingdom. Teen and pop papers and magazines were full of pictures and interviews with the boys. Les McKeown, Eric Faulkner, Alan Longmuir, Derek Longmuir and Stuart 'Woody' Wood certainly weren't the greatest singers or musicians, but they were hugely popular especially with young girls. They set a whole new fashion look with their trademark tartan-trimmed shirts and wide-legged trousers.

The Bay City Rollers had massive hits with songs including 'Shang-a-Lang' and 'Bye, Bye, Baby', and sold over 60 million records before they broke up in 1982.

Alexander Graham Bell

Best remembered as the inventor of the telephone, Alexander Graham Bell was born in South Charlotte Street in Edinburgh in 1847, the son of an elocution teacher. He attended the Royal High School and then went on to the University of Edinburgh.

The family moved to London when Alexander was aged eighteen. His life was threatened by tuberculosis (which his brother had died from), and in 1870 the family moved to Ontario in Canada after doctors suggested the change of climate might provide a cure. In 1871 Alexander Graham Bell moved to the United States, and was appointed Professor of Vocal Physiology at Boston in 1873. He devoted himself to teaching the deaf.

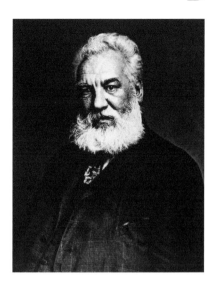

Inventor of the telephone, Alexander Graham Bell. Photographer unknown. (© National Galleries of Scotland)

He produced the first intelligible electronic transmission, to his assistant, on 5 June 1875 with the words, 'Mr Watson – come here – I want to see you.' He patented the telephone the following year at the age of twenty-nine, and formed the Bell Telephone Company in 1877. Within three years of this, Edinburgh had its first telephone system, operating from an exchange in St Andrew Square.

In 1888, Thomas Edison's carbon microphone greatly improved the performance of Bell's telephone, and in return Bell improved Edison's phonograph. Bell worked on many other inventions, but it is for the telephone that he will be remembered most widely. Bell died on 2 August 1922 in Nova Scotia, Canada.

Deacon Brodie

William Brodie, born in 1741, was a highly respected Edinburgh citizen, a cabinetmaker by trade, deacon of the Wrights and Masons of Edinburgh, and a city councillor who socialised with the gentry. However, by night this respected man was a burglar. As part of his work as a cabinetmaker, he installed and repaired locks and was able to make copies of keys, which he then used to access the homes and businesses of well-off citizens at night to relieve them of cash and valuables.

Despite having a successful business, Brodie needed this extra income to support his gambling habit, and also his two mistresses and their five children.

His burglary sideline was successful and no one ever suspected him, and he took on three accomplices – Smith, Brown and Ainslie. They continued with their robberies until 1788, when Brodie planned an armed raid on the Excise Office in the Canongate, along with his three partners in crime. The raid went wrong: they were nearly caught, eventually escaping with only £16 between the four of them rather than the thousands they had anticipated. Shortly after this, Brown (who was under

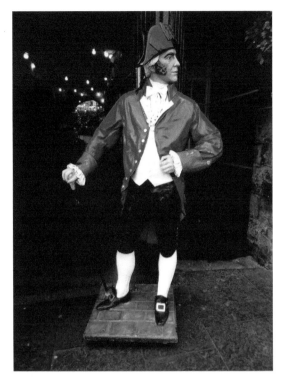

Life-sized figure of Deacon Brodie at the entrance to Brodie's Close.

sentence of transportation for a crime he had committed in his native England) saw an advertisement offering a reward and pardon to any person who had information regarding a recent robbery at the shop of Inglis & Horner. He turned in Smith and Ainslie, but didn't give Brodie's name initially as he hoped to procure money from him in return for secrecy. Brodie meanwhile, fearing arrest, had fled the country, via London to the Netherlands, intending to escape to the United States, but was arrested in Amsterdam and shipped back to Edinburgh to await trial. The tools of his burglary trade were found in his workshop and this, along with Brown's testimony, was sufficient evidence to find him guilty and he was sentenced to death by hanging. Ironically, this took place on a gibbet, which he himself had recently designed, in front of a crowd of 40,000 on 1 October 1788. It was rumoured that he had bargained with the executioner for a shorter rope so that he would only be rendered unconscious rather than dead and that after the body was cut down, it was driven around at a furious rate in an attempt to jolt him back to life. There were also rumours that he wore a steel collar and a silver tube inserted in his throat to prevent his death. However, Brodie was found dead after the hanging, and his body was buried in an unmarked grave at Buccleuch Church in Chapel Street – now covered over by a car park.

The story of Deacon Brodie was said to be the inspiration for R. L. Stevenson's *The Strange Case of Dr Jekyll and Mr Hyde*, which was published in 1886.

Deacon Brodie's name lives on in a local pub, a café, and in Brodie's Close in the Lawnmarket.

Burke and Hare

Although they were both Irishmen, the names of William Burke and William Hare are forever linked with Edinburgh as a result of the sixteen horrific murders they committed over a ten-month period in 1828.

Watchtower in St Cuthbert's Churchyard, Lothian Road.

Both Burke and Hare had come to Edinburgh from Ireland and worked as labourers on the building of the Union Canal, although they don't appear to have met at this time and may have met later when they both, along with their common-law wives, moved into the same lodging house in Tanner's Close. They became friends and had something of a reputation for hard drinking and boisterous behaviour.

At this time Scotland was a centre of anatomical study, where demand for fresh cadavers was outstripping the legal supply. Scottish law required that corpses for medical research should only come from those who had either died in prison, were suicide victims, or were foundlings and orphans. This shortage led to an increase in grave robbing by resurrection men, which in turn led to an increased need for protection of newly buried bodies by mortsafes, which covered the graves, and watchtowers being built in graveyards.

When a lodger in Hare's house died of natural causes, owing him money, he and Burke decided to sell the body to Dr Robert Knox, and realised what a lucrative trade supplying bodies could be. They then turned to murder to keep up the supply of bodies, which Knox accepted with no questions asked, and for which they received up to £10 per body. Their method of choice was suffocation, which left no marks on the bodies. One of their victims, James Wilson known as 'Daft Jamie', was recognised by students in Dr Knox's anatomy class, but Knox denied that it was him. Burke and Hare's actions were only eventually discovered when some of the other lodgers found their last victim and called the police. The police investigated but could find no evidence to convict Burke and Hare of this or any previous murders. Hare, however, was offered immunity by the Lord Advocate if he turned King's evidence, and he readily confessed to having committed all sixteen murders along with Burke. Burke was tried for three of the murders and found guilty of one, which was enough for him to be sentenced to death. He was hanged in January 1829 and his corpse was dissected, then the skeleton put on display in the Anatomical Museum at the University of Edinburgh's Medical School, where it remains to this day. A pocket book was made from a tanned piece of his skin, which is on display in the History of Surgery Museum, along with his death mask.

As for Hare, he was released and assisted to leave Edinburgh in disguise. He possibly changed his name, and his eventual fate is unknown.

Knox was cleared of complicity by a Committee of Inquiry, but resigned from his position and later left Edinburgh.

C

Calton Hill

Calton Hill, in the city centre not far from the East End of Princes Street, is 338 feet (103 metres) high and gives spectacular panoramic views of the city and beyond. It is home to an eclectic collection of buildings and monuments, including the National Monument, City Observatory, Nelson Monument and Dugald Stewart Monument.

The name Calton is believed to have a Celtic origin, meaning 'place of groves'.

Rock House, at the Waterloo Place entrance to Calton Hill, was the home of Robert Adamson who, together with David Octavius Hill, pioneered the calotype process of photography in the 1840s and Calton Hill was the location for many of their photographs. In 1829, The Royal High School was built on the southern slopes of

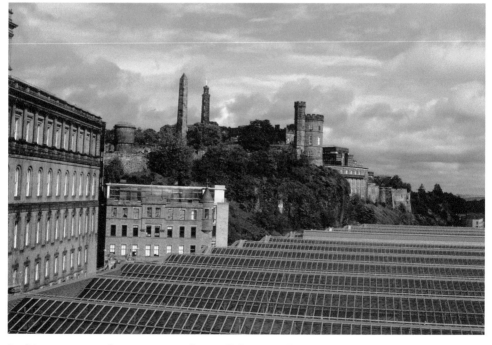

Looking over Waverley Station to Calton Hill from North Bridge.

View northwards from Calton Hill, with Fife in the distance.

the hill. Calton Hill is also the name of a street just off Waterloo Place, which contains a small group of houses dating from the 1760s.

Calton Hill is used as a venue for several events throughout the year, in particular the Beltane Fire Festival on 30 April each year, which revives an ancient Celtic celebration marking the changing seasons. Unfortunately, other than the occasions when there is a special event taking place, Calton Hill is generally considered by many not to be a safe area to visit after dark.

Camera Obscura

The Camera Obscura and World of Illusions is a tourist attraction in Castlehill that combines both old and modern science in a historical building.

The four lower floors survive from two seventeenth-century tenements. In the early 1850s, Maria Short, whose family were scientific instrument makers, bought this property, added two storeys, installed a camera obscura on top of it and then held exhibitions inside, calling it Short's Observatory and Museum of Science and Art. It opened to the public in 1853, and the tower containing the camera obscura was the main attraction from the start. In 1892, Patrick Geddes, a famous town planner and sociologist, bought the tower in a public auction. He renamed it the Outlook Tower because he wanted to change people's outlook. He reinvented it as a sociological

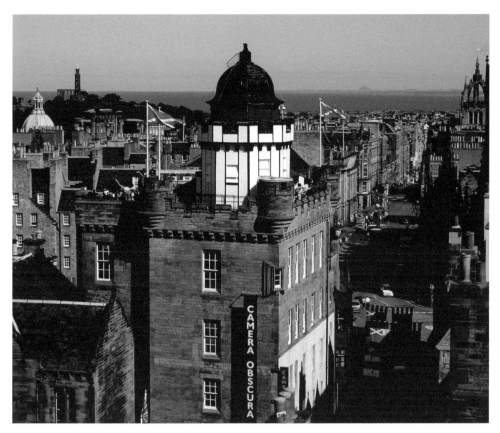

Camera Obscura, Lawnmarket. (© Camera Obscura and World of Illusions)

laboratory with exhibits, where he encouraged visitors to learn about the city and its place in the world. It was a popular attraction but closed after his death in 1932, when the property was sold to a private owner. Edinburgh University owned the tower from the 1940s to 1982; it was then sold to a private company, who now operate the attraction.

The camera obscura allows you to see live moving images of Edinburgh projected onto a viewing table through a system of mirrors and lenses, just as it did in Victorian times. It is the oldest purpose-built attraction in the city, although many of the attractions in the World of Illusions of course make use of modern technology. From the rooftop, powerful telescopes allow you to see the surrounding city close up.

Candlemaker Row

In the sixteenth century, when the Corporation of Candlemakers was established in Edinburgh, candles were traditionally made by boiling up tallow, which consisted of leftover products from the fleshers (butchers). This created a terrible stench, as well

Convening Hall of Corporation of Candlemakers, Candlemaker Row.

as being a considerable fire risk in the densely populated streets and closes of old Edinburgh. In 1621, the town council passed an act requiring all candlemakers to work outwith the town. At that time, the street now known as Candlemaker Row was outwith the boundaries of the town and regarded as a suitable location, so the candlemakers set up their businesses there. At one time, virtually all the properties on the west side of the street belonged to the Corporation of Candlemakers for use as workshops, shops and dwellings for their members.

A convening hall for the Corporation of Candlemakers was built at the top of Candlemaker Row, close to the entrance to Greyfriars Kirkyard, in 1722, where it still remains today. The arms of the craft, now very worn, are carved over the doorway above the motto '*Omnia manifesta luce*' ('Everything clearly seen').

Charlotte Square

Charlotte Square, at the West End of George Street, is considered the 'jewel in the crown' of the New Town. It was named after Queen Charlotte, wife of George III, the reigning monarch at the time the New Town was planned in 1767. The town houses

on each side of the square were designed by Robert Adam as unified blocks, creating palace-like frontages, and the square itself was built around a large private garden.

The building of Charlotte Square was completed in 1820, and early residents were mainly landed gentry, followed by middle-class professionals. Many notable people have lived here, including Lord Cockburn, Joseph Lister and Field Marshall Earl Haig. By the mid-twentieth century much of the property was in commercial use, especially by lawyers and financial institutions.

On the north side of the square No. 6 is Bute House, the official residence of the First Minister of Scotland, and No. 7 is the National Trust for Scotland's Georgian House.

Closes

Closes in Edinburgh's Old Town are narrow alleyways, sometimes leading to open courtyards, which were often closed off by a gate. The narrowness of the closes, combined with the tall buildings on either side, made these very dark and gloomy places. Closes were often named after either a trade carried out there – such as Fleshmarket Close – or a notable resident, for example Brodie's Close.

Many of the old closes are now sealed off or are merely remembered by a name on the wall, but the ones that are still open to the public are well worth exploring, either on your own or as part of a guided tour. They are full of atmosphere and history, and give a feel of what living in the claustrophobic conditions of the Old Town many centuries ago may have been like.

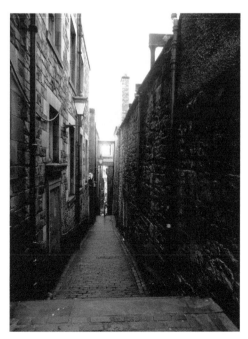

Looking down Anchor Close from High Street.

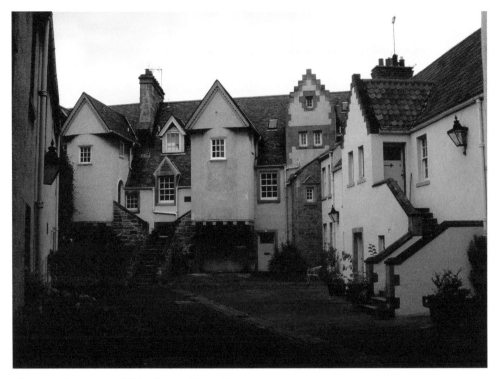

The very picturesque White Horse Close, Canongate.

Sean Connery

Thomas Sean Connery was born into a working-class family in the Fountainbridge area of the city on 25 August 1930. He is reported as having said that his family was very poor, but he didn't realise it at the time as everyone around them was poor. His first job was to deliver milk for St Cuthbert's Co-operative Society ('the Co-op'), and if the memories of all the people who claim he was their milk boy are correct, he must have had the largest milk round in the city! Sean left school at an early age, and at sixteen he enlisted into the Royal Navy. His time in the Navy, however, was shortened by illness, and after three years he returned to Edinburgh.

He then had a variety of jobs, including bricklayer, coffin polisher and lifeguard. He was a keen bodybuilder, and often acted as a model for the Edinburgh College of Art. His good looks and physique earned him chorus parts and small theatrical roles, but it was not until his first role as James Bond in *Dr. No* in 1962 that Sean Connery became a household name. He has made over seventy films in total, earning multiple BAFTAs, Golden Globes and Academy Awards.

Sir Sean Connery was knighted in 2000 for Services to Film, and announced his retirement from acting in 2006 when being awarded the American Film Institute's Lifetime Achievement Award.

Despite not having lived in Scotland for several decades, Sean Connery remains a loyal supporter of the Scottish National Party and Scottish independence. Although the tenement where he was born was demolished in the 1960s, there is a plaque on the wall of a new building on the site to mark his achievement.

Craigmillar Castle

Edinburgh Castle is certainly the city's most famous and most visited castle, but Craigmillar Castle, which lies some 3 miles south-east of the city centre, is well worth a visit too. It is one of the best preserved medieval castle ruins in Scotland. The oldest part is an L-shaped tower house dating from the late fourteenth or early fifteenth century, which was built for the Preston family. An inner courtyard wall was later built and there were extensive additions over the following 250 years. As well as being a stronghold, the castle was also a very comfortable residence, surrounded by fine gardens.

Craigmillar Castle has a connection with Mary, Queen of Scots, who sought refuge there in 1566 after the murder of her secretary, David Rizzio, and it was allegedly where the plot to murder her husband, Lord Darnley, was hatched. In these days it was very much a rural retreat and, although it is now well within the city of Edinburgh, the approach is still very much like a country lane. In the early eighteenth century,

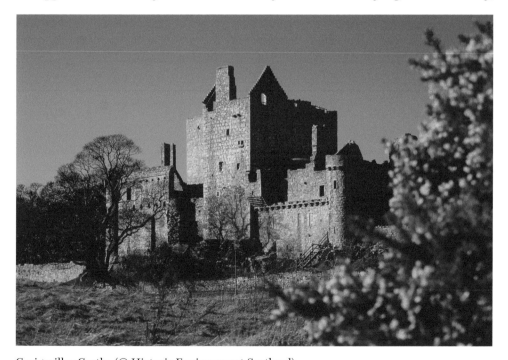

Craigmillar Castle. (© Historic Environment Scotland)

Inner courtyard, Craigmillar Castle. (© Historic Environment Scotland)

the Gilmour family (who owned it at the time) decided to abandon Craigmillar Castle and move to the newly built Inch House. The castle was later advertised 'to let', but by 1775 it had become a ruin.

The five-storey building has many rooms, a multitude of nooks and crannies to explore and turnpike stairs to climb.

Craigmillar Castle is now in the care of Historic Environment Scotland.

D

Dean Village

The Dean Village (from 'dene', meaning 'deep valley') is a very picturesque area in a valley of the Water of Leith. It is very close to the West End of Princes Street, but once you go down the hill into the valley you could easily be miles away from anywhere.

Previously known as the Water of Leith Village, and with its first mill probably dating back to the twelfth century, this was a very successful grain milling area, with eleven working mills at one time. It was later also used by tanners. However, trade diminished when larger and more modern flour mills were built at Leith and the

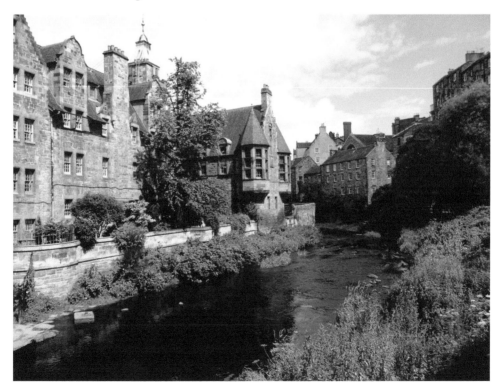

Dean Village, with Well Court on left.

village fell into decay, with the last tannery closing in the 1960s. A programme of development and restoration took place from the mid-1970s, and it is now a very attractive and desirable place to live. Cobbled streets and lanes remain, and new housing has been very sympathetically designed to fit in well with the old restored buildings.

Well Court, in the centre of the village, was built in 1886 as model housing for local workers, along with 'a hall to encourage social interaction and community spirit among the tenants'. It underwent major restoration in 2007–09. There was also a school in the village, which has now been turned into housing.

Dean Village is a beautiful place for a walk, but please bear in mind these are people's homes and respect their privacy.

Dolly the Sheep

Arguably the world's most famous sheep, Dolly was the first mammal to be cloned from an adult somatic cell. It was the result of research by Ian Wilmut and his colleagues at the Roslin Institute, part of the University of Edinburgh, and the biotechnology company PPL Therapeutics.

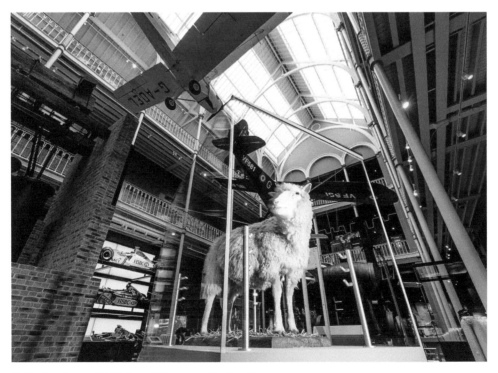

Dolly the sheep. (© National Museums Scotland)

Dolly was born on 5 July 1996, although her birth was not announced to the public until 22 February 1997. She was named after Dolly Parton, as the cell used as a donor was taken from a mammary gland!

Dolly lived her entire life at Roslin Institute, where she was bred with David, a Welsh Mountain ram, and gave birth to a total of six lambs. At the end of 2000, along with other sheep at Roslin, Dolly became infected with a virus that causes lung cancer in sheep. In 2001 she developed arthritis, which was successfully treated with anti-inflammatory drugs, and she remained well until she developed a cough in February 2003. A CT scan showed tumours in her lungs, and the decision was made to euthanise her. Dolly was euthanised on 14 February 2003.

Dolly's body was donated to the National Museum of Scotland, where she is now on display in a glass case.

Although Dolly is remembered for being a clone, the main legacy of the research at the Roslin Institute has not been the cloning of animals, but advancements into stem cell research.

Arthur Conan Doyle

Arthur Ignatius Conan Doyle was born in Picardy Place, Edinburgh, on 22 May 1859 into a prosperous Irish Catholic family. His mother, May, was well educated and passionate about books and loved storytelling. At the age of nine Arthur was sent to a Jesuit boarding school, where he was unhappy, but where he realised he also had a talent for storytelling.

On leaving school, Arthur decided to follow a medical career and became a student at the University of Edinburgh. It was while studying there that he met Dr Joseph Bell, who was one of his tutors, and who, with his mastery of observation, logic, deduction and diagnosis, was to become the inspiration for Sherlock Holmes. While a student, Arthur decided to try writing short stories, and when his first two were accepted for publication he realised he could make money from his writing. Nevertheless, he continued with his studies, graduating in 1880 with the degree of Bachelor of Medicine and Master of Surgery, and went on to have a career in medicine.

In 1888, his first novel, *A Study in Scarlet*, was published and Sherlock Holmes was introduced to the world. He continued to write short stories about Holmes, which were published in *The Strand* magazine, and which gained him many followers and fame. During this time he continued to practise medicine but eventually, after a serious bout of influenza in 1891, he decided to abandon medicine for writing and had a very successful career as an author.

Arthur Conan Doyle died on 7 July 1930. He is commemorated in Edinburgh with a statue of Sherlock Holmes, which was unveiled in 1991 close to where his birthplace in Picardy Place was located.

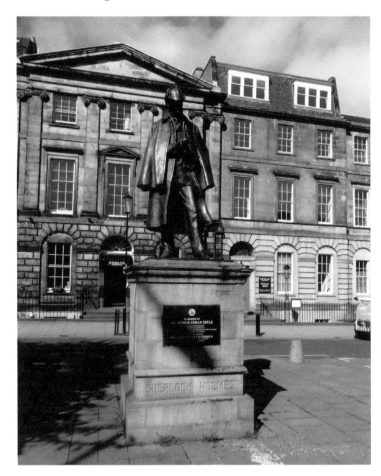

Sherlock Holmes statue, Picardy Place – a memorial to Sir Arthur Conan Doyle.

Duddingston

Originally called Treverlen, the land in this area belonged to a gentleman called Dodin de Berwic in the 1150s, who called himself Dodin de Dodinestoun, 'toun' being early Scots for a farm place. Although part of Edinburgh, it is still known as Duddingston Village, and is a picturesque conservation area that is full of history.

Duddingston Kirk dates from the early twelfth century and outside is a seventeenth-century 'loupin-on-stane' to help people get on and off their horses, and the 'jougs' (a punishment collar). The kirk also has a nineteenth-century gatehouse that was used as a lookout to watch for body snatchers. In the grounds of Duddingston Kirk is Dr Neil's Garden, which was created on a steep, rocky site by doctors Andrew and Nancy Neil, and is a beautiful, peaceful place where you can sit quietly in contemplation.

The house where Prince Charles Edward Stuart held his council of war before the Battle of Prestonpans in 1745 is also in the village, and is called Prince Charlie's Cottage.

Lane leading to Duddingston Village.

Above: Duddingston Kirk.

Left: The 'loupin-on-stane' outside Duddingston Kirk.

E

Edinburgh Castle

The most famous and most iconic building in Edinburgh sits on a volcanic rock overlooking the city.

So much of Scotland's history, both ancient and more modern, took place here or is remembered here – the Stone of Destiny, Prisons of War and Scottish National War Memorial, to name only a few. The oldest building in Edinburgh, St Margaret's Chapel, which was built around 1130, is within the castle. Mary, Queen of Scots gave birth here in 1566 to the future James VI, who was to become James I of England after the Union of the Crowns in 1603. From the 1600s onwards the castle was a military base with a large garrison, and parts of it are still a military base today.

The Castle Rock is believed to have been inhabited since 900 BC, as there is evidence of Bronze Age settlers having been there. The castle changed hands several times between the Scots and the English during the Scottish Wars of Independence in the late thirteenth and early fourteenth centuries, and was captured by Covenanters in the seventeenth century.

Edinburgh Castle is one of the most visited tourist attractions in Scotland, with over 1.7 million visitors in the last financial year, and generates a significant sum of money each year through entrance fees, food and drink sales, and shops, as well

Edinburgh Castle from Princes Street. (© Historic Environment Scotland)

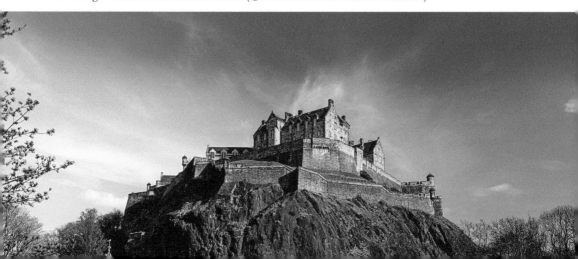

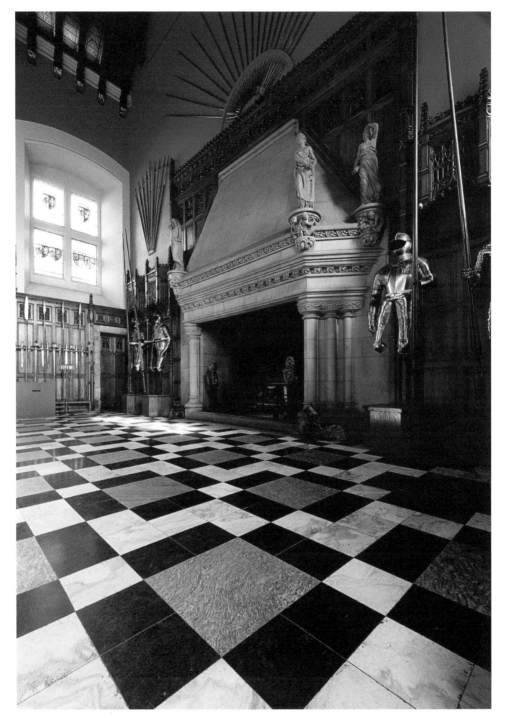

Above: The Great Hall, Edinburgh Castle. (© Historic Environment Scotland)

Opposite: A sweet treat – Edinburgh Rock.

as venue hire. You can arrange private hire for banquets, dinners and other special events. You can even arrange to be married in St Margaret's Chapel and have your reception in one of the historic rooms. It's hard to believe now that not so many years ago admission to the castle was free, with a charge of 6*d* (2.5p) if you wanted to enter the historic apartments.

Edinburgh Rock

Edinburgh Rock is a popular confection, which is very different from traditional seaside rock. It doesn't have 'Edinburgh' written all the way through, is pastel coloured, soft and crumbly, and is made from sugar, water, cream of tartar, and flavourings and colourings. The traditional flavours are orange, lemon, raspberry, vanilla and ginger.

Edinburgh Rock was first made and sold in the nineteenth century by Alexander Ferguson, a confectioner who set up his business in Edinburgh and became extremely successful, being a very rich man by the time he retired.

The only local company making Edinburgh Rock nowadays is Ross's of Edinburgh, a confectionery company founded in 1880. Their 'Edinburgh Castle Rock' is sold in their iconic yellow and tartan box, which they introduced in 1947 to celebrate the first Edinburgh International Festival.

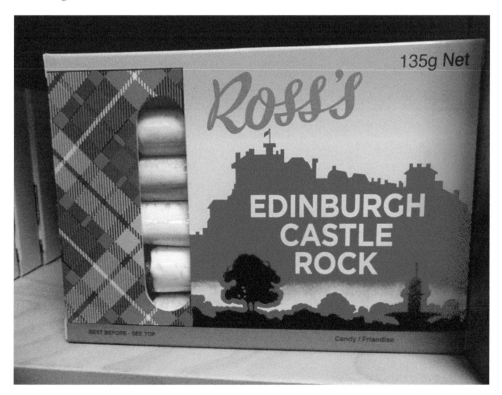

Festivals

Whether you love them or hate them, there is no escape from festivals in Edinburgh.

The Edinburgh International Festival was established in 1947 as a cultural event to bring together audiences and artists from around the world. It was also seen as a chance for Edinburgh to establish a new identity after the Second World War as 'the cultural resort of Europe'. Performance at the festival was by invitation only, and right from the beginning artists who had not been invited to be part of the official programme were inspired to put on shows of their own, eight of them in that first year, and these events grew into the Edinburgh Festival Fringe. In 2017, the number of Fringe shows had grown to almost 3,400. The Edinburgh International Film Festival also started in the same year.

Fringe performers promoting their show in the Royal Mile.

The year 1950 saw the first Edinburgh Military Tattoo, which takes place in the spectacular setting of the Castle Esplanade, and now attracts audiences of over 200,000 each year.

The Jazz Festival (now Jazz & Blues Festival) was set up in 1978 and has become a firm favourite with performers and audiences from all over the world.

In 1983 the Book Festival was added, taking place every year in Charlotte Square where you can enjoy workshops, listen to readings and talks by authors or take part in debates.

The year 1989 saw both Science and Storytelling being added to the list of festivals, followed by the Children's Festival in 1990 and the Hogmanay Festival in 1994. The latest addition has been the Art Festival in 2004. With all this going on, Edinburgh truly deserves its title of 'Festival City'.

Flodden Wall

Following the Scots' defeat by the English at the Battle of Flodden in 1513, an English invasion of Edinburgh was widely anticipated and it was agreed a new town wall should be built. Work started the following year, but it was not completed until 1560.

The wall originally ran from the south side of the castle, running across the west end of the Grassmarket, continuing uphill along the Vennel. It then ran east, through what are now the grounds of George Heriot's School, around Greyfriars Kirkyard, to Bristo Port and Potterow Port. Continuing eastwards, it passed Kirk O'Field (where Old College now stands) and along Drummond Street, turning north at the Pleasance,

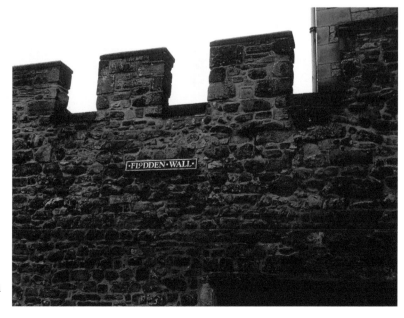

Part of the Flodden Wall in The Vennel.

then up St Mary's Street to Netherbow Port. It then continued northwards to the Nor' Loch, which formed a natural boundary and defence on the north side of the town.

The wall enclosed an area of some 140 acres with a population of around 10,000, and this area remained the limit of the burgh until the eighteenth century.

There were six ports (gateways) in the Flodden Wall, above which the limbs and heads of executed criminals were regularly displayed.

Parts of the Flodden Wall still survive today, one of the best preserved of these being at the junction of Drummond Street and the Pleasance, along with the Flodden Tower in the Vennel.

Floral Clock

The floral clock, situated in West Princes Street Gardens at the foot of The Mound, is believed to be the first of its kind. It was designed in 1903 by James McHattie, the City Superintendent of Parks, and James Ritchie, an Edinburgh clockmaker whose company still services the clock to this day. The clock mechanism is housed inside the plinth of the statue of Allan Ramsay, which stands beside it; until 1973, when an electric motor was installed, it had to be wound up every day. The bird house and life-sized replica of a cuckoo that calls every fifteen minutes were added in 1952.

The clock is a beautiful piece of horticultural art, which is planted out each year on a topical theme, using up to 40,000 plants that are specially grown in the city's Inch Nursery.

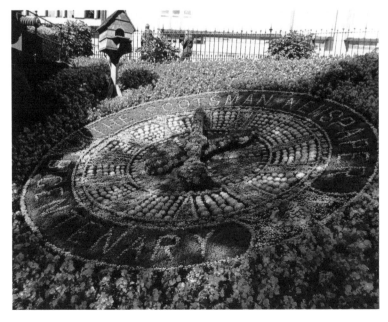

The Floral Clock, Princes Street Gardens, in full bloom.

G

Gabriel's Road

The route known as Gabriel's Road was first recorded in 1717 as a loan that led from Mutrie's Hill (the site of Register House) to Silvermills. Sections of this ancient route still exist today at West Register Street by the side of the Guildford Arms and Café Royal, the right of way through the grounds of the Royal Bank of Scotland in St Andrew Square, and at Glenogle Road in Stockbridge. The roads now called East and West Silvermills Lane were part of it too. The origin of the name unfortunately remains unknown.

Above left: Gabriel's Road at East End of Princes Street.

Above right: Gabriel's Road at Stockbridge, leading down to Glenogle Road.

The Georgian House

You can step back in time to the late eighteenth century when you enter the Georgian House at No. 7 Charlotte Square.

This National Trust for Scotland property has been beautifully restored to how it would have looked at the time of its first owner, John Lamont, who purchased it for £1,800 in 1796. The house was designed by Robert Adam and is a typical Edinburgh New Town house of the late eighteenth and early nineteenth centuries.

You are free to look round the house at your own pace when you visit, and there are trained voluntary guides in the main rooms to answer your questions or tell you more about the rooms and their luxurious furniture and furnishings.

Left: The Georgian House, Charlotte Square. (© National Trust for Scotland)

Below: Drawing Room in the Georgian House. (© National Trust for Scotland)

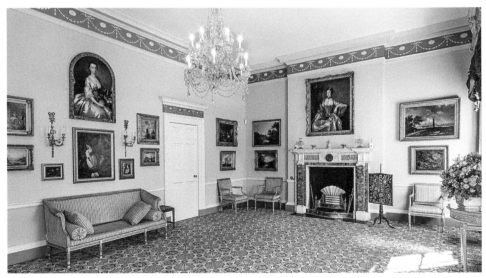

It's not all glamour, though, as you can also visit 'below stairs' and see the well-equipped kitchen and scullery, where the servants would have worked long hours to keep the master and his family living their comfortable lifestyle.

Gladstone's Land

This six-storey tenement house in the Lawnmarket was originally built in 1550. In 1617 it was bought by the merchant Thomas Gledstanes, who remodelled and extended the building to attract wealthy tenants for his apartments, shops on the ground floor and tavern in the basement. It is a rare surviving building from that time, as many of the tenements were destroyed in the Great Fire of Edinburgh in 1824.

The National Trust for Scotland rescued Gladstone's Land from demolition in 1934. During restoration work, original Renaissance painted ceilings were uncovered. Today the building gives a glimpse of seventeenth-century Old Town life, complete with an arcade frontage and reconstructed shop booth. The entrance sign has a hawk with outstretched wings, the name Gledstanes coming from the Scots word 'gled', meaning 'hawk'.

At the time of writing, visits to Gladstone's Land are by pre-booked tour only.

Gladstone's Land, Lawnmarket.
(© National Trust for Scotland)

The Painted Chamber, Gladstone's Land. (© National Trust for Scotland)

Grassmarket

Lying in the shadow of Edinburgh Castle, the area now known as the Grassmarket was originally referred to as Newbygging (new buildings) under the castle in the 1300s,

The pedestrianised north side of Grassmarket.

and was outside the city walls. The Grassmarket was in use as a marketplace from the 1400s, originally used for cattle fairs. The name of Grassmarket may have come from the fact that the livestock grazed there.

As a gathering point for market traders and cattle drovers, the Grassmarket was traditionally a place of taverns, inns and temporary lodgings. It was also the place where public executions were carried out. Most of the buildings now are from improvements made to the Old Town in the 1800s, although the White Hart Inn and some other buildings on the north side date to the 1700s. Until fairly recently it still had a number of hostels for the homeless and was generally a quite rundown and undesirable area. Now, however, it is a lively area with many popular bars and restaurants, most of which have outside seating. It retains its links with the past as it is still used for outdoor markets.

Greyfriars Bobby

Famous as the subject of several books and films, Bobby was a Skye terrier who reputedly spent fourteen years guarding the grave of his owner, John Gray, after his death from tuberculosis and burial in Greyfriars Kirkyard in 1858 until Bobby's own death in 1872.

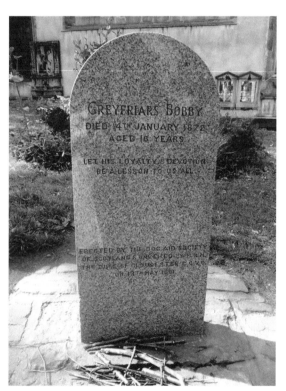

Greyfriars Bobby's gravestone in Greyfriars Kirkyard.

Bobby was fed daily in the local coffee house he had frequented with his master, and the sound of the one o'clock gun was his signal to leave the kirkyard and head off for his lunch. He became something of a local celebrity and visitors flocked to see the loyal dog and, of course, brought in welcome business to the coffee house too.

In 1867, a bye-law was introduced requiring dogs to be licensed, and the Lord Provost of Edinburgh himself, Sir William Chambers, paid for Bobby's licence and bought him a collar, which is now on display in the Museum of Edinburgh.

When Bobby died he was buried just inside the gate of Greyfriars Kirkyard, not far from his master's grave. A year later, Lady Burdett-Coutts, an English philanthropist and animal-lover, was touched by the story of Bobby's loyalty and paid to have a drinking fountain, topped with a life-sized statue of Bobby, erected close to the kirkyard at the junction of George IV Bridge and Candlemaker Row. It had an upper fountain for humans and a lower one for dogs, but the water supply was cut off around 1975 amid public health fears.

In recent years the veracity of Bobby's story has been questioned by some academics, but regardless of whether or not all the details are correct, the story of the little Skye terrier has touched hearts across the world. (If you do go to visit Bobby, please, please don't rub his nose. It's not a tradition, no matter what tour guides may tell you, and it causes damage to the statue.)

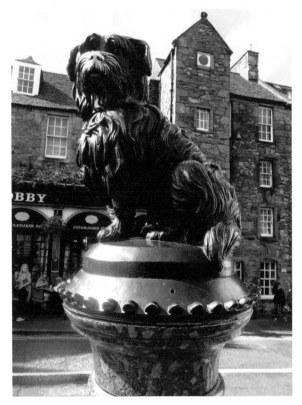

Greyfriars Bobby statue, at junction of Candlemaker Row and George IV Bridge.

Hogmanay

New Year's Eve – Hogmanay – has always been an important time of year in Scotland and was the main winter festival to be celebrated. Traditionally, people would visit friends and neighbours, and the 'first foot' (the first person to visit the house after midnight had struck) was very important. The first foot would bring gifts of food, drink and a piece of coal to wish the householder luck and prosperity for the coming year. There would also be entertainment, mainly of the home-made variety, with music and song.

In Edinburgh, the Tron was a popular meeting place at Hogmanay, where people would wait for the clock bells to ring out at midnight and wish each other a happy New Year. This has, however, largely died out in recent years and been replaced by a massive street party centred around Princes Street Gardens, with live bands, entertainment and a fireworks display.

Holyrood Park

Holyrood Park is a 650-acre royal park in the city centre, which contains Arthur's Seat, Salisbury Crags and three lochs – Duddingston, St Margaret's and Dunsapie.

When Holyrood Abbey was founded in 1128, the area was described as forested. The area became a hunting estate associated with the Palace of Holyroodhouse, and the park was created by James V in 1541 when he had the ground enclosed by a stone wall. As recently as the beginning of the nineteenth century, the park was still a wild place, covered with rough vegetation and sheep farms. Queen Victoria and Prince Albert used to stay at the palace, and in 1844 he organised various improvement schemes including drainage of marshes and the creation of St Margaret's Loch and Dunsapie Loch, clearance of vegetation, and the building of the roadway now known as Queen's Drive.

Human occupation of the park seems to date back to the Stone Age, with artefacts from both then and the Bronze Age having been found within the park. Holyrood Park

Holyrood Park.

had agricultural use for many centuries, the last trace of this being removed when the last sheep left the park in 1977.

In the early sixteenth century the park became a debtors' sanctuary, which debtors could leave for twenty-four hours a week on the Sabbath without fear of arrest. As laws on debt changed over time, use of the sanctuary gradually decreased and it had fallen into disuse by the end of the nineteenth century. Interestingly, though, the sanctuary rights of Holyrood Park were never repealed, so technically debtors could still try to escape from their creditors there!

Salisbury Crags are 151-foot-high (46-metre) cliffs of dolerite and columnar basalt that were quarried for many years, until in 1831 the House of Lords ruled that Lord Haddington (the Keeper of the Park) had no right to remove stone from the park. The Radical Road, a footpath at the base of the crags, was laid out in the aftermath of the Radical War of 1820, using the labour of unemployed weavers from the west of Scotland.

In parts of the centre of the park, you can neither see nor hear the noise of the city and could easily imagine yourself to be in the wilds of the countryside. The whole of Holyrood Park is a Site of Special Scientific Interest and a Scheduled Ancient Monument, and is under the care of Historic Environment Scotland.

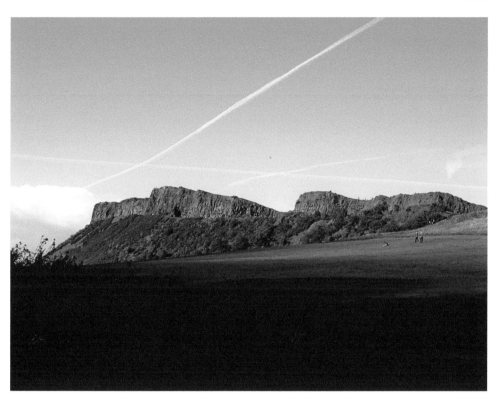

Salisbury Crags in Holyrood Park.

Elsie Inglis

Elsie Maud Inglis was born in 1864 in Naini Tal, India, where her father was a civil servant. The family later moved to Tasmania, and then Edinburgh. With her father's encouragement, Elsie started her training as a doctor at the Edinburgh School of Medicine for Women, and completed her training at the Glasgow Royal Infirmary. In 1892 she took the exams of the Royal College of Physicians and Surgeons of Edinburgh and the Faculty of Physicians of Glasgow, which she passed with high marks. She set up practice in Edinburgh, and in 1904 opened a small hospital for poor women

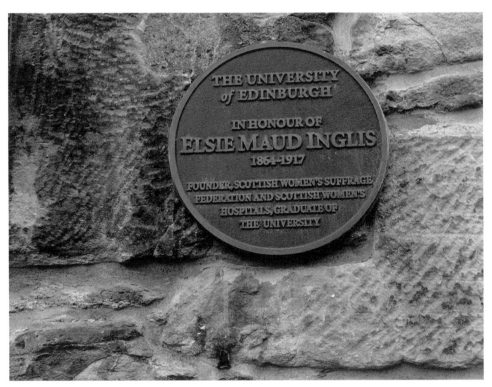

Memorial plaque for Elsie Inglis in Surgeons' Square.

and children, staffed entirely by women. In 1905 Elsie accepted a consultant post at Bruntsfield Hospital in Edinburgh.

She was a political activist through the suffrage movement, and was able to use her connections to raise money for the Scottish Women's Hospitals. She travelled all over Scotland giving lectures. In 1914 she raised £25,000 (a vast amount of money in these days) in a single month, and offered her all-women Scottish Field Hospital to the War Office, who refused.

When the Red Cross appealed for medical aid for Serbia, Elsie was quick to go. She tried valiantly to improve public hygiene and was appalled at the open drains and contaminated water supplies. Her hospital fell into Austrian hands, but she refused to leave her Serbian patients and went into captivity with them. She was repatriated and then formed the Scottish Women's Hospital Unit, which served in Odessa.

Sadly, Elsie Inglis died of cancer the day after returning to Britain in 1917, and was buried in Edinburgh's Dean Cemetery.

The Elsie Inglis Memorial Maternity Hospital in Abbeyhill, Edinburgh, was founded in 1925. It closed in 1988, but the name of Elsie Inglis is remembered by many thousands of Edinburgh citizens who gave birth or were born at 'Elsie's'.

Jenners

Jenners was founded by Charles Jenner and Charles Kennington in 1838, and was originally known as Kennington & Jenner. The story goes that a win on the horses at Musselburgh Races provided sufficient capital for Englishmen Kennington and Jenner to give up their jobs in an Edinburgh draper's shop and purchase the lease on a converted town house on the corner of Princes Street and South St David Street. The original buildings were destroyed by fire in 1892 and the present building opened in 1895. It had many innovations at the time, including electric lighting and hydraulic lifts. It has of course greatly expanded since it originally opened, taking in more and more neighbouring properties over the years.

Jenners was always renowned for its quality and tradition, and was a favourite place for ladies to meet for lunch or afternoon tea, followed by a browse round its many departments. A trip to the toy department was a treat for many children, especially at Christmas, even if it was only to look. There was a certain magic to the store, with its many levels and different areas making it very different to more modern stores.

The Douglas-Miller family, who had run the store for many years, sold it to House of Fraser in 2005, ending its reign as the oldest independent department store in Scotland. Although it still trades under the Jenners name, it has perhaps lost something of that magic and uniqueness.

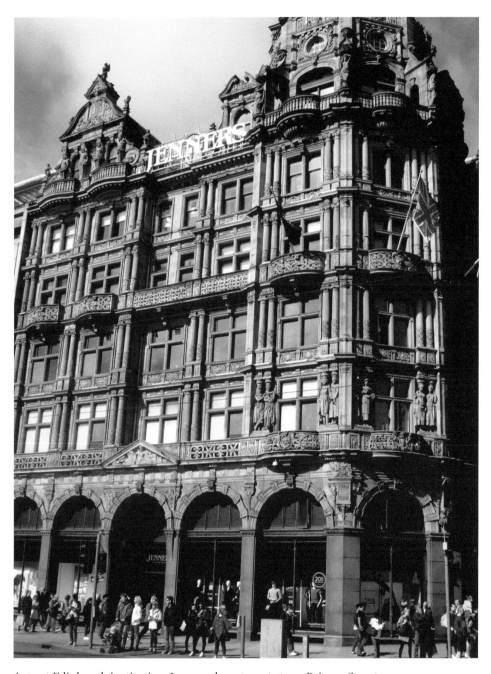

A great Edinburgh institution: Jenners department store, Princes Street.

Kilns

Portobello was one of the main centres of industrial ceramic production for over two centuries. The last two surviving pottery kilns in Scotland – built in 1906 and 1909 – are situated in Bridge Street, Portobello, the only remains of A. W. Buchan & Co., which closed down in 1972. Buchans started out in 1878 producing utilitarian stoneware, then moved into decorative stoneware after the Second World War. Their best-selling design was their pattern known as 'Thistle', which was popular both at home and abroad. The goods became known as Thistle Ware and the name of the works was changed to the Thistle Pottery in 1955.

A restoration project to restore the kilns as a memorial to the Portobello pottery industry and as an important part of Scotland's industrial heritage was completed in 2014. The kilns are 39 feet (11.8 metres) high and some 23 feet (7 metres) in diameter at the base.

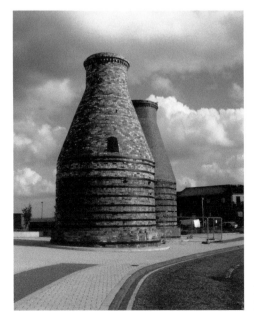

Restored pottery kilns at Bridge Street, Portobello.

Lauriston Castle

Lauriston Castle is a sixteenth-century tower house with nineteenth-century extensions, overlooking the Firth of Forth near Davidson's Mains. The interior remains as it was in 1926, when the last private owner, Mrs Reid, died and left it to the nation. William Reid, a cabinetmaker and keen collector of furniture, and his wife Margaret had moved into Lauriston Castle in 1902. They amassed large collections of beautiful items, including ceramics and Sheffield plate, which are now on display along with personal items such as photographs and books. The Reids had no children and had agreed with Mrs Reid's brother that the last of them surviving would bequeath Lauriston Castle to the nation. Lauriston Castle is now in the care of the City of Edinburgh Council and is open by guided tour only. It is set in 30 acres of grounds that

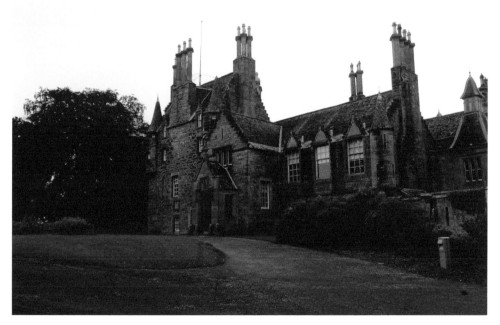

Main entrance to Lauriston Castle.

Entrance to Lauriston Castle gardens.

were laid out in the 1840s and are open to the public free of charge. There is a year-round programme of lectures, arts and crafts events, and gardening events as well as costumed events where the former owners and staff of the house welcome you to visit them.

Leith

Although now part of Edinburgh, Leith was separate until 1920, with its origins dating back to medieval times. Leith became a major port in 1296 after Edward I destroyed Berwick, which up until then had been the principal port in Scotland and the base for exporting of wool from the Border Abbeys. Undeterred by this, the monks sent the wool north to Leith, thus establishing it as an important port. Leith remained the principal port in Scotland until Glasgow took over in 1707.

Leith was attacked by an English army in 1544 then again in 1547, and as a result fortification work was begun. By 1559 Leith was a walled town. In the early seventeenth century, North and South Leith (on opposite sides of the mouth of the Water of Leith) both became parishes. In 1649 work was begun on a line of defences stretching from Edinburgh to Leith, which would later become Leith Walk. This line was defended for

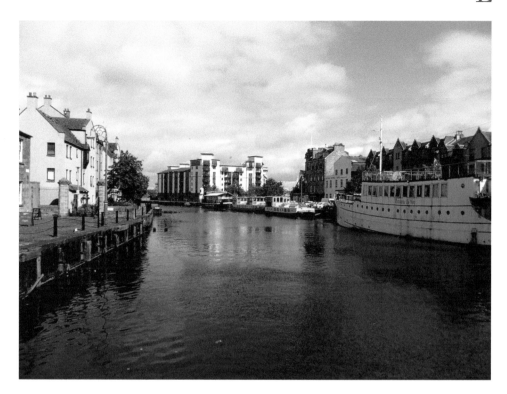

Above: The Shore, Leith, from Bernard Street Bridge.

Right: Lamb's House, Leith, a restored seventeenth-century merchant's house.

three weeks against Oliver Cromwell's men, but after the Scots' defeat at the Battle of Dunbar, both Leith and Edinburgh surrendered to Cromwell. The Citadel in North Leith was built for Cromwell.

After a threat by a fleet led by John Paul Jones, a fort was constructed in North Leith to defend against future attacks. During the Napoleonic Wars, a Martello tower was built as defence.

The first dry docks were constructed in the 1770s, and the first wet dock opened in 1806. Leith was a centre of the whaling industry for several centuries, and other important industries included shipbuilding, whisky storage (with over eighty bonded warehouses in the 1960s) and soapmaking (which used whale oil in its production).

There are many fine buildings in Leith, especially from the 1800s, many of which are connected with the life of a port, including the Custom House, Signal Tower and the Sailors' Home (now the Malmaison Hotel).

Leith became an independent burgh in 1833, and in 1920 it very reluctantly amalgamated with Edinburgh. People from Leith, however, are very proudly still Leithers. For many years, Leith was a working-class area with a great deal of poverty, but in recent years with a great deal of new building it has become very much an up-and-coming area and a fashionable place to live.

Eric Liddell

Eric Liddell was born on 16 January 1902 to Scottish missionary parents in China, and at the age of six was sent to school in London, along with his older brother Robert. At school, Eric Liddell proved to be an outstanding athlete and rugby player.

Liddell studied Pure Science at the University of Edinburgh, during which time he became known as the fastest runner in Scotland. He has been described as being strikingly handsome, with powerful legs, strong shoulders and arms – the perfect build for a sprinter.

Known as the 'Flying Scotsman', Liddell was the hot favourite to win the 100 metres at the 1924 Summer Olympics in Paris. However, the qualifying heats were on a Sunday and Liddell refused to compromise his profound Christian faith by taking part – the Sabbath was sacrosanct to him. He did, however, go on to run in the 400 metres, for which the heats were held on a Monday, winning a Gold medal with a world record time of 47.6 seconds.

After the Paris Olympics, Liddell graduated from the University of Edinburgh with a Bachelor of Science degree. He returned to China in 1925 to carry out missionary work, marrying in 1934. He died of an inoperable brain tumour in a Japanese prison camp in occupied China on 21 February 1945, only a few months before the end of the war.

Eric Liddell was portrayed by Scottish actor Ian Charleson in the 1981 Oscar-winning film *Chariots of Fire*. The Eric Liddell Centre in Morningside was set up in 1980 to honour Liddell's beliefs in community service while he lived and studied in Edinburgh.

M

Mary King's Close

The name of this close dates from the seventeenth century, but it is uncertain why it is so named. It had previously been Alexander King's Close, but there is no record of him having either a wife or daughter called Mary.

One story goes that the residents of the close were struck by plague in 1645 and the city council decided to halt the spread of the disease by bricking the close up and leaving the victims there to die. The houses remained closed for several generations, and it became a place of mystery and horror. There have been many stories of hauntings over the years, including a disembodied head, a blood-dripping arm that protruded from a wall, and many other terrifying spectres.

The close was partially demolished when building of the Royal Exchange (now the City Chambers) commenced on top of it in 1753, although the northern portion was still an open ruin in 1845. The warren of underground streets remained hidden for a long time, although certainly in the latter part of the twentieth century a private tour could be arranged through City Council officials.

Since 2003 a tourist attraction has operated there called 'The Real Mary King's Close', where costumed guides give tours of the underground streets and tell tales of their history.

Mary, Queen of Scots

Mary, Queen of Scots is often regarded as a romantic, tragic figure, and there was certainly plenty of drama in her short life, some of which took place in Edinburgh. Mary Stuart was born in Linlithgow, West Lothian, on 8 December 1542, one week before the death of her father, and was crowned Queen of Scotland at Stirling Castle at the tender age of nine months old on 9 September 1543. Her mother, Mary of Guise, was appointed to rule as regent on behalf of the infant queen. Mary was initially betrothed to Prince Edward of England, son of Henry VIII, but Scottish Catholics objected to this plan as England had separated from the Catholic Church. When the match was annulled, England attacked Scotland in raids that became known as 'The Rough Wooing'.

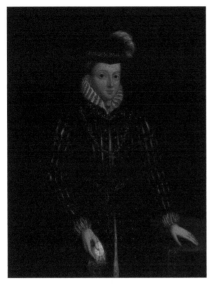

Mary, Queen of Scots. Artist unknown. (© National Galleries of Scotland)

Mary's mother was French, and the Scots had a long-standing alliance with France, so at the age of five Mary was betrothed to Henri II's son Francois, the four-year-old Dauphin of France, in return for the promise of her safety in France. Mary and Francois were married in 1558, and in 1559 Henri II died and Francois became King of France at the age of fifteen, with Mary as his queen. Francois himself died the following year, and Mary lost her right to the French crown. Her mother had also died earlier in 1560, and with her mother-in-law, Catherine of Medici, now ruling France as regent for her son Charles IX, Mary decided to return to Scotland to fulfil her duties as Queen of Scotland. One can't help wondering how differently history may have turned out had Francois not died so unexpectedly of an ear condition at only sixteen years old.

Mary arrived in Leith on 19 August 1561, earlier than expected, and found no one there to meet her. She was taken to nearby Lamb's House to rest and wait. The following day she was escorted to the Palace of Holyroodhouse, which was to be her home for the next seven years. This was where she married her cousin, Henry Stuart, Lord Darnley, and where her secretary David Rizzio was stabbed to death. After Rizzio's murder, the heavily pregnant queen moved to Craigmillar Castle for some respite, before then moving to Edinburgh Castle, where she gave birth to her son James, the future James VI of Scotland and James I of England, on 19 June 1566.

Lord Darnley died in mysterious circumstances in February 1567, when his body was found after the house he was staying in at Kirk O'Field was blown up, but he had been strangled. Only three months later, Mary married the Earl of Bothwell, who had been accused of murdering Darnley. Soon thereafter, Bothwell was captured and Mary was taken to Lochleven Castle as a prisoner.

In June 1567, while imprisoned in Lochleven Castle, Mary was forced to abdicate in favour of her infant son, James, and shortly after suffered a miscarriage. Mary managed to escape from Lochleven Castle the following year, and sought help

from her cousin, Elizabeth I, but was instead arrested and held captive for the rest of her life, until her execution at Fotheringhay Castle on the orders of the queen on 8 February 1587 at the age of forty-four.

The Mound

The road now called the Mound is an artificial hill connecting the Old and New Towns of Edinburgh.

It started out life around 1780 as an unofficial shortcut from the Old Town to the developing New Town and was formed from the dirt and rubble excavated from the foundations of the New Town being piled into the former Nor' Loch, and became known as the Earthen Mound. This was extended over the years until by 1830 it was tarred and the area landscaped. Tunnels were driven under the Mound when the railway was extended to Waverley in 1846.

In 1959, an 'electric blanket' was installed under the surface of the roadway to keep the steep hill clear of ice and snow in the winter, at a cost of around £7,000, but the decision was taken in the 1970s to remove this because of heavy repair costs. Every December, the Christmas tree at the top of the Mound is a focal point. The tree is gifted from Hordaland County Council in Norway, to mark the support given by Scotland to Norway during the Second World War.

Looking up the Mound from Princes Street.

John Napier of Merchiston

John Napier, famed mathematician, physicist and astronomer, was born in Merchiston Tower in Edinburgh in 1550, the 8th Laird of Merchiston.

He is best remembered as the inventor both of logarithms, which were meant to simplify calculations such as those needed in astronomy, and also of 'Napier's Bones', a forerunner of the slide rule.

Napier was interested in theology and was a staunch Protestant. Due to some of his religious beliefs, some people regarded him as a magician, and he was thought to have dabbled in alchemy and necromancy. He also had a rooster, which was thought to be his familiar. He died in Edinburgh in 1617.

Merchiston Tower still stands, and is now part of Napier University's campus.

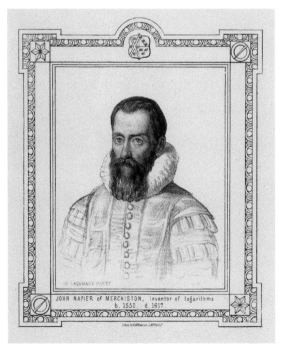

John Napier of Merchiston. Artist unknown. (© National Galleries of Scotland)

National Galleries of Scotland

Edinburgh has three galleries under the umbrella of 'National Galleries of Scotland', namely the Scottish National Gallery, Scottish National Portrait Gallery and The Scottish National Gallery of Modern Art. The galleries are home to one of the world's finest collections of Western art from the Middle Ages to the present day, which includes the national collection of Scottish art. As well as housing a world-class collection of art, the gallery buildings are quite outstanding themselves.

The Scottish National Gallery comprises both the National Gallery Building and the Royal Scottish Academy Building. Both of these buildings, designed by William Henry Playfair, stand at the foot of the Mound. Although originally built as separate structures, since 2004 they have been physically connected by the underground Gardens Level.

The Scottish National Gallery of Modern Art is likewise housed in two separate buildings, on opposite sides of Belford Road. Modern One is housed in the former John Watson's School, a neoclassical building designed by William Burn in 1825. The lawn at the front of the building was landscaped to a design by Charles Jencks and is home to a sculpture park. Modern Two was originally built in 1833 as the Dean Orphan Hospital, and was converted into a gallery in order to show the Gallery of Modern Art's extensive collection of Dada and Surrealist art and work by the sculptor Eduardo Paolozzi, and includes a recreation of his London studio.

The Scottish National Portrait Gallery is a great red sandstone neo-Gothic palace at the end of Queen Street. The gallery was designed by Sir Robert Rowand Anderson as a shrine for Scotland's heroes and heroines, and opened to the public in 1889 as the world's first purpose-built portrait gallery. John Ritchie Findlay, the chief proprietor of *The Scotsman* newspaper, not only paid for the construction and an endowment, but he also masterminded the building that was to house the collection.

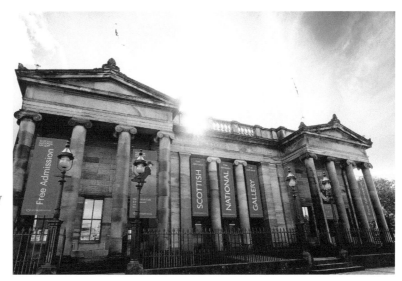

National Gallery of Scotland by Eoin Carey. (© National Galleries of Scotland)

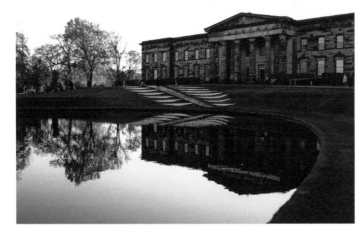

Scottish National Gallery of Modern Art – Modern One by Gregory Steadman. (© National Galleries of Scotland)

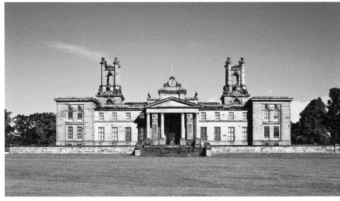

Scottish National Gallery of Modern Art – Modern Two by Keith Hunter. (© National Galleries of Scotland)

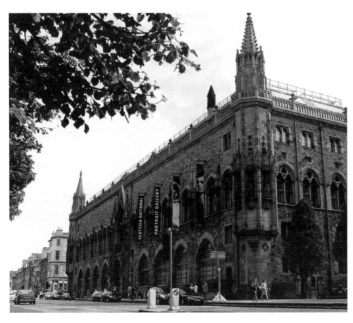

Scottish National Portrait Gallery, Queen Street. (© National Galleries of Scotland)

Admission to all of the galleries is free, although there may be charges for special exhibitions. They all have shops and pleasant cafés, and run an extensive programme of talks, tours and other activities. If you need encouragement to visit all of them, there is a gallery bus that runs a circular route taking in all three of the galleries.

National Monument of Scotland

The National Monument, situated on Calton Hill, is not, as you may think, a ruin, but rather a monument that was never actually completed.

It was planned as a national monument to Scotland's soldiers and sailors who died fighting in the Napoleonic Wars, designed by Charles Robert Cockerell and William Henry Playfair, and was modelled on the Parthenon in Athens. There were also plans to have catacombs beneath, where prominent figures could be buried.

It was estimated that the cost of building would be £42,000 and subscribers were sought to raise funds. The materials were to be of the top quality, which of course meant they would be very expensive. With only one third of the necessary funding having been raised, a foundation stone weighing 6 tons was laid in 1822, construction started in 1826 and, due to the lack of funds, work stopped in 1829 with only the base and twelve columns completed. Because of this, it is often referred to locally as 'Edinburgh's Disgrace'. There were various proposals during the early twentieth century that building should be completed as a different monument or memorial, or that it should actually be finished off as a building, but none of these went ahead and it remains in its unfinished state.

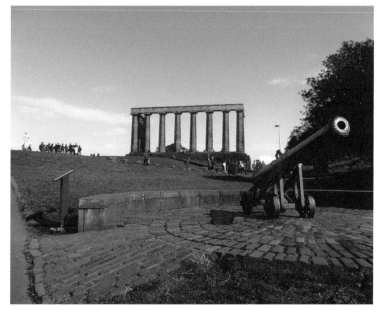

National Monument
of Scotland and
Portuguese Cannon,
Calton Hill.

National Museum of Scotland

The museum building in Chambers Street is an interesting juxtaposition of a Victorian building and a late twentieth-century addition, housing collections of national and international importance.

The original building was designed by Francis Fowke in Victorian Romanesque Revival style, the foundation stone was laid in 1861 by Prince Albert, and it opened as the Edinburgh Museum of Art and Science in May 1866. In 1904 it was renamed the Royal Scottish Museum. In 1998 the Museum of Scotland opened in the new adjoining building designed by Benson & Forsyth, in a modernist geometric design, but with references to traditional Scottish castellated architecture. In 2006 the two museums merged to form the National Museum of Scotland.

The National Museum of Scotland tells Scotland's story from prehistory to the present day and beyond in a series of galleries that include Art, Design & Fashion, Science & Technologies, and Natural World, with many hands-on activities, talks, and guided tours.

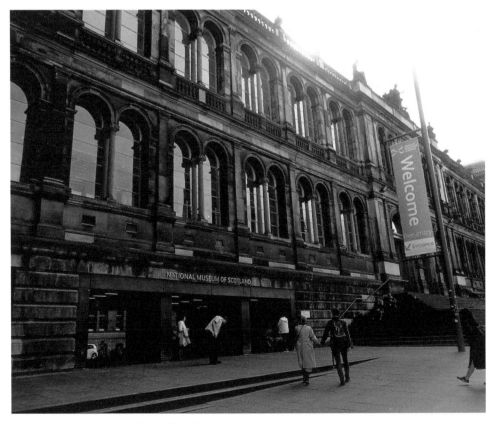

National Museum of Scotland, Chambers Street.

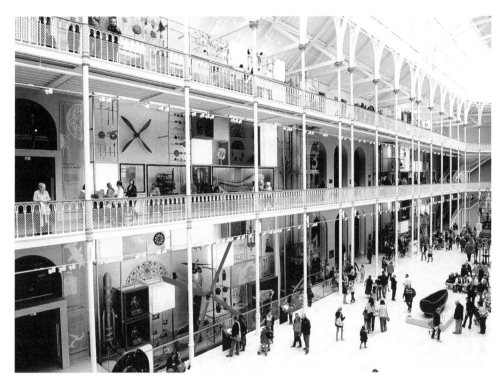

Grand Gallery, National Museum of Scotland. (© National Museums Scotland)

The New Town

What qualifies as 'new' in Edinburgh would probably be regarded as positively ancient in other places. The New Town was built as a necessary alternative to the cramped and overcrowded conditions within the city walls. It was also hoped that having new spacious housing would prevent wealthy citizens leaving Edinburgh for London, as well as encouraging those who had already left to return. In 1766 a competition was held for designs for a New Town, which was won by a young architect, James Craig, and the first building was Thistle Court, built in 1767, which still stands. Craig's design was a simple grid system, in stark contrast to the Old Town, with wide streets running east to west and north to south, and narrow service lanes in between. Although some alterations were made to his plan, the New Town largely follows that original design. It was originally envisaged as being a residential area, but the commercial potential was soon realised, and now Princes Street, George Street and many of the others are main shopping areas.

The New Town was built in stages from 1767 to the mid-1800s, and much of the original Georgian and neoclassical architecture remains today. A copy of Craig's plan can be seen in the Museum of Edinburgh.

One o'Clock Gun

At 1 p.m. daily – except for Sundays, Christmas Day and Good Friday – a gun is fired across Princes Street from the Mills Mount Battery at Edinburgh Castle. It's said that you can easily tell locals from visitors at this time, as visitors will jump whereas locals calmly check their watches!

The one o'clock gun dates back to 1861, when it was an audible signal to complement the Calton Hill Time-Ball, which was of no use in foggy or misty weather, to allow ships in Leith and the Firth of Forth to set their maritime clocks. Although such a time signal is no longer necessary, it has become part of Edinburgh Castle's traditions, and watching the ceremony is a popular tourist attraction.

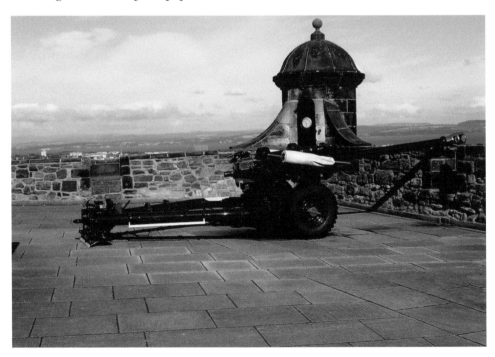

One o'clock gun at Edinburgh Castle.

P

Palace of Holyroodhouse

Commonly referred to as Holyrood Palace, the Palace of Holyroodhouse is the British monarch's official residence in Scotland. It has a royal history going back many hundreds of years.

Its origins go back to royal chambers, which were attached to Holyrood Abbey. James IV decided to convert the chambers into a palace, but nothing survives today of his palace. In 1528, during the reign of James V, work began on a huge tower that provided a high degree of security and is the oldest part of the building surviving today. The west front was rebuilt and the south remodelled during his reign.

During the reign of James VI, repairs were carried out and the gardens were improved and enlarged. Buildings that had originally been part of the abbey were absorbed into the palace, and it was renovated further for the Scottish coronation of James's son, Charles I, in 1633.

Part of the palace was abandoned after a fire in 1650, when Oliver Cromwell and his soldiers were there.

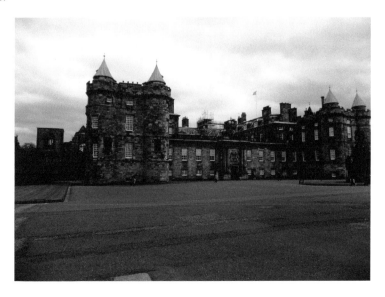

Main frontage of the Palace of Holyroodhouse.

When Charles II was restored to the throne in 1660, Holyrood became a royal palace again, and rebuilding began in 1671. The design of today's palace owes a great deal to the blend of old and new buildings at that time. By 1679 the whole palace had been reconstructed, largely in its present form.

Queen Victoria was very fond of Holyrood, and she organised a programme of interior renovation, with a further programme of improvements being carried out after the First World War.

The palace is open to the public throughout the year, except when members of the royal family are in residence. It remains the property of the Crown.

Eduardo Paolozzi

Eduardo Paolozzi was born in Leith in 1924, the son of immigrants from the Cassino area of Italy. In June 1940, when Italy declared war on the United Kingdom, he was interned along with most other Italian men in Britain.

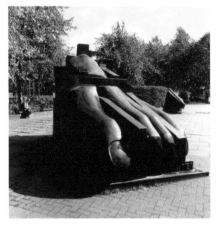

Eduardo Paolozzi's foot sculpture.

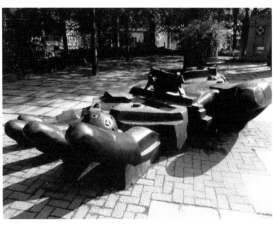

Eduardo Paolozzi's hand sculpture.

After his release, Paolozzi studied at Edinburgh College of Art in 1943, followed by a brief spell at St Martin's School of Art in 1944, and then at the Slade School of Fine Art from 1944 to 1947, after which he worked in Paris for some time. He then moved to London, where he established his studio in Chelsea.

His 1947 collage, *I was a Rich Man's Plaything* is considered to be the first standard bearer of pop art.

While Paolozzi worked in a variety of media, he became most closely associated with sculpture.

He was knighted in 1989, and in 1994 he donated a large body of his work and much of the contents of his studio to the Scottish National Gallery of Modern Art, where it is on display in Modern Two.

Eduardo Paolozzi died in London in 2005. During his lifetime he had carried out commissions for many pieces of public art, and the three-part group called *The Manuscript of Monte Cassino* consisting of a huge foot, an ankle and an upturned hand with an open palm stands outside St Mary's Cathedral at the top of Leith Walk.

Portobello

Many visitors to Edinburgh don't realise that the city has its own seaside – Portobello, some 3 miles to the east of the city centre, facing the Firth of Forth.

The area got its name when a cottage was built in 1742 on what is now the High Street by a seaman who had served during the 1739 capture of Porto Bello, Panama, meaning literally 'beautiful port or harbour', and who named the cottage Portobello Hut in honour of that victory.

Portobello beach on an overcast summer day.

Portobello was once a town in its own right, but in 1896 was incorporated into the city of Edinburgh. In its heyday as a resort, at the end of the nineteenth century and into the twentieth century, it was extremely popular with visitors from both Edinburgh and Glasgow. By the 1960s it had a popular funfair and amusement arcades, which, with its promenade and wide sandy beach, added to its attraction for many. However, with the advent of cheap package holidays abroad, the number of people spending their holidays in Portobello dwindled during the 1970s.

Between 1846 and 1964, a railway station provided ready access for visitors to the resort, whose facilities came to include a very popular large open-air heated swimming pool, which was heated by spare heat from the nearby power station. The art deco pool opened in 1936, and closed in 1979. In 1901 Portobello Baths were opened on The Promenade, overlooking the beach. The baths, now known as Portobello Swim Centre, are still open to the public and are home to one of only three remaining operational Turkish baths in Scotland.

Although Portobello no longer attracts the huge crowds it did in the past, it is still a popular day out for many people from Edinburgh and the surrounding areas.

Princes Street

Princes Street has probably one of the most beautiful aspects for a main city street, looking southwards across Princes Street Gardens to Edinburgh Castle and the Old Town. It is the southernmost street of the New Town, but sadly many of the Georgian buildings were destroyed when there was a plan in the 1960s to introduce a first-floor walkway and the original buildings were replaced with modernist shop buildings. This plan was stopped in the 1970s, and only a few disconnected parts of the walkway were ever built.

During construction of the New Town, the Nor' Loch was drained and the area was cultivated into private gardens. Princes Street Gardens were taken over by the City Council in the late nineteenth century, by which time most of the street had become commercial and there was no longer any need for private gardens for residents. The gardens are now a welcome place to sit or walk in the city centre, and popular with local shop and office workers as somewhere to sit and eat lunch or to sunbathe on warm enough days. The gardens contain many statues and memorials, as well as an open-air theatre. There is a parliamentary order that prevents any further building on the south side of Princes Street, to protect the open views across to the castle and Old Town.

Princes Street was originally to be called St Giles Street in honour of Edinburgh's patron saint, but George III did not like this as it suggested to him an unsavoury area of London; Prince's Street was suggested instead – for the Prince of Wales. The spelling seems to have been variable over the years as Prince's, Princes' and Princes, but the present form became the accepted one from the 1830s.

Princes Street Gardens, looking south to the Old Town.

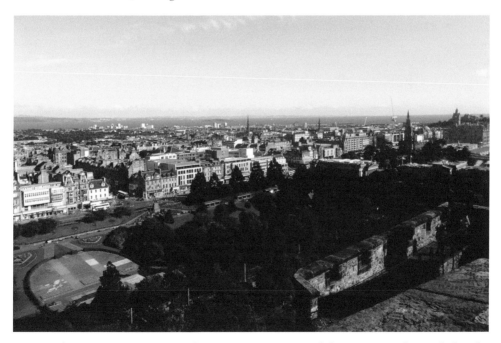

View north over Princes Street Gardens to Princes Street and the New Town from Edinburgh Castle.

Queen Mary's Bath House

Legend says that this odd little building jutting out into the pavement near Holyrood Palace was where Mary, Queen of Scots liked to bathe in sweet white wine.

A poem of 1770 describes it as:

> That chamber where the queen, whose charms divine
> Made wond'ring nations own the power of love,
> Oft bathed her snowy limbs in sparkling wine,
> Now proves a lonely refuge for the dove.

The reality is a bit more prosaic, however. Built in the late sixteenth century and restored in 1852, the two-storey building, which was once attached to the boundary wall of the King's Privy Garden of the Palace of Holyroodhouse, was most likely a lodge or summer pavilion.

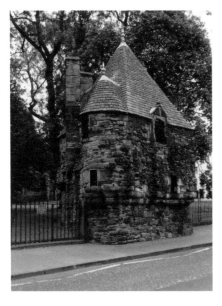

Queen Mary's Bath House.

R

Ramsay Garden

Ramsay Garden, adjacent to Edinburgh Castle and overlooking Princes Street, has the appearance of buildings in a romantic medieval fairy tale, with its steep pitched roofs and gabled turrets. However, it was built in the 1890s by renowned town planner Sir Patrick Geddes as part of an urban renewal project. Part of the Ramsay Garden development was for student housing, and other parts were available to the public. The Geddes family themselves lived there in a twelve-room apartment. Ramsay Garden incorporated the house that the poet Allan Ramsay built for himself in 1740 (nicknamed Goose Pie because of its octagonal shape) and a terrace added by his painter son, also Allan Ramsay, in 1768.

Ramsay Garden from Princes Street.

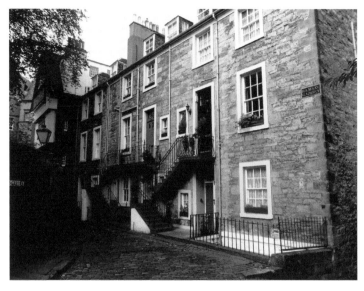

Ramsay Garden.

Ian Rankin

Author Ian Rankin is, like his most famous creation John Rebus, an incomer to Edinburgh from Fife, but has made his home here and been accepted as 'one of our own'.

Ian was born in Cardenden, Fife, in 1960 and studied literature at the University of Edinburgh, graduating in 1982. He started working towards a PhD in Scottish Literature, but became involved in writing his own novels instead. He has won many crime-writing awards as well as receiving honorary degrees from several universities, and being awarded an OBE for Services to Literature.

John Rebus first appeared in *Knots and Crosses* in 1987 and has since been the subject of many Ian Rankin novels as well as TV adaptations. Ian has also written short stories, a graphic novel and a play.

Ian Rankin. (© Hamish Brown)

While Rebus is very different from Ian in character – being a pessimistic, flawed, maverick police officer – they do share some similarities, notably their love of music and a drink or two in the Oxford Bar.

The Rebus books are written in real time, which allows them to be tied into actual events, political and social, while still remaining gripping crime novels that always delve into the darker side of Edinburgh and its citizens.

J. K. Rowling

Joanne Rowling is probably one of Edinburgh's most famous current residents. The Harry Potter author moved to Edinburgh with her young daughter in 1993, to live with her sister and brother-in-law after divorcing her first husband.

Jo famously wrote much of her first novel while sitting in Edinburgh coffee shops with her daughter by her side. It is said that the names of some of her characters were inspired by reading gravestones in Greyfriars Kirkyard. She had wanted to be a writer from a very young age, and says that the whole idea of Harry Potter came to her spontaneously while on a train journey.

The novels were published under the name of J. K. Rowling (the 'K' is for her grandmother, Kathleen) as the publishers felt that boys would be more likely to read books by someone with a neutral name, rather than an obviously female one. It certainly worked, as the Harry Potter novels went on to become the fastest selling books in history, and Harry Potter has become a global brand worth billions of dollars.

Jo also writes a successful crime novel series under the name Robert Galbraith. As a writer, J. K. Rowling has been an incredible success, but her own story has also been an inspiring one. She was responsible for millions of children taking a real interest in reading. She has gone from living on benefits in a small rented flat to being a multimillionaire. She has her own charitable trust and has been involved with and donated large sums of money to other charities.

Harry Potter author J. K. Rowling. (© Mary McCartney, 2015)

Royal Botanic Garden

The Royal Botanic Garden Edinburgh, or 'The Botanics' as they're more popularly known locally, was first established close to Holyrood Abbey in 1670 as a physic garden by two doctors, Robert Sibbald and Andrew Balfour. They wanted the garden in order to train physicians in the use of herbal remedies. After a few moves, The Botanics settled in their home at Inverleith in 1820. They now have three other sites outwith Edinburgh, with a total of over 15,000 different plant species; they are all primarily centres for plant science, horticulture and education, but are also just beautiful and peaceful places for anyone to visit.

The Botanics at Inverleith covers over 70 acres of landscaped grounds, with major features including a rock garden, glasshouses and a Chinese Hillside garden. They are also home to a variety of wildlife, including very tame squirrels. Entrance is free, with a small entry charge for the glasshouses. The Botanics is a lovely place for a walk or quiet seat at any time of year and is pretty much guaranteed to be peaceful as there are no dogs allowed (except assistance dogs), no bikes, scooters, running or football.

Royal Infirmary of Edinburgh

The first Edinburgh Infirmary was paid for by public funds and opened at the head of Robertson's Close (off the present day Infirmary Street) in 1729. It was a tiny hospital, having only four beds. In 1736 it became the Royal Infirmary of Edinburgh when a royal charter was granted by George II, and soon thereafter a new hospital was commissioned. In 1741, the new 228-bed hospital opened in what was later to be called

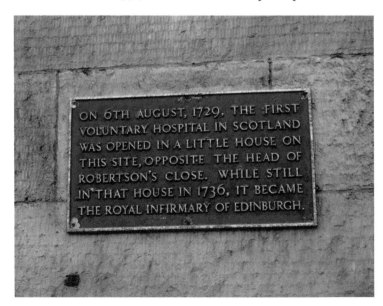

Plaque marking the site of the first voluntary hospital in Scotland at Robertson's Close.

Infirmary Street. Over the years, this expanded to occupy most of the area between the present-day Infirmary Street and Drummond Street.

By the 1860s this was still not enough to cope with demand, and plans were being drawn up for a new hospital. In the early 1870s, architect David Bryce was asked to design a new Royal Infirmary on a site at Lauriston Place. His plans were heavily influenced by the pavilion model advanced by Florence Nightingale.

The Royal Infirmary of Edinburgh moved to the new site at Lauriston Place in 1879 and this was complemented by the Edinburgh Royal Maternity Hospital, the city's first purpose-built maternity facility. By 1910, the maternity hospital was struggling to cope and expanded into nearby flats, and in 1939 the new Simpson Memorial Maternity Pavilion opened next to the main hospital.

Despite modernisation and expansion over the years, it became widely recognised that the old-fashioned Victorian hospital was in need of replacement, and in 1998 agreement was reached that a new Royal Infirmary would be built at Little France, which would incorporate the Princess Margaret Rose Orthopaedic Hospital and the City Hospital.

The new 900-bed Royal Infirmary of Edinburgh opened in 2002 and the old hospital site at Lauriston Place has been redeveloped as Quartermile, a development of flats, offices, and shops with a mixture of renovations and new builds. Its history is recognised in the new street names, which include Simpson Loan, Nightingale Way and Lister Square.

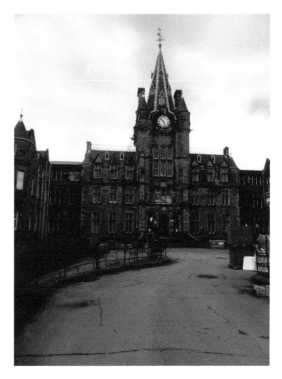

Old Royal Infirmary, Lauriston Place.

Royal Mile

Approximately 1 Scots mile in length, the Royal Mile sits on a ridge that was formed by the retreat of an ice age millions of years ago. The Royal Mile is the ancient heart of Edinburgh, and is a collective name for the succession of streets that run down from the royal residences of Edinburgh Castle to the Palace of Holyroodhouse – Castlehill, Lawnmarket, High Street, Canongate and Abbey Strand.

Everywhere you walk in the Royal Mile, you are surrounded by history, and when you enter some of the closes (alleyways) that lead off both sides of the street, you could easily feel as though you are stepping back in time. It has many tourist attractions and museums, as well as a multitude of shops selling everything Scottish from luxury cashmere goods to shortbread and whisky. It is important to remember, however, that this part of Edinburgh is still home to many people and there have been concerns expressed that everything is becoming geared towards visitors rather than the people who actually live here.

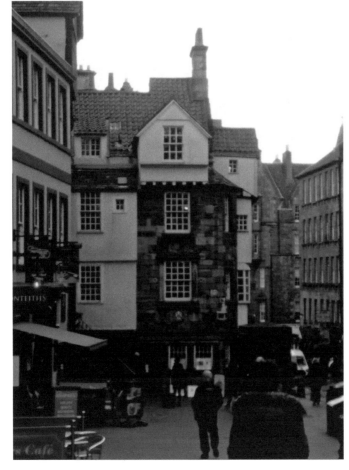

John Knox's House, High Street, Royal Mile.

St Cecilia's Hall

Originally commissioned by the Edinburgh Musical Society and designed by Robert Mylne, St Cecilia's Hall at the foot of Niddry Street was opened in 1763. It is the oldest purpose-built concert hall in Scotland and was named after the patron saint of music.

As well as a music hall, the building had variously been used as a church, Masonic hall, school, ballroom and warehouse before being purchased by the University of Edinburgh in 1959.

Now newly renovated as a concert room and music museum, St Cecilia's Hall is said to be the only place in the world where you can hear eighteenth-century music played on eighteenth-century instruments in an eighteenth-century concert hall. The emphasis of the museum is on instruments that are no longer in regular current use, and it is one of the world's most important collections of historic musical instruments.

St Cecilia's Hall has a programme of events, concerts and education workshops, and is also available for hire.

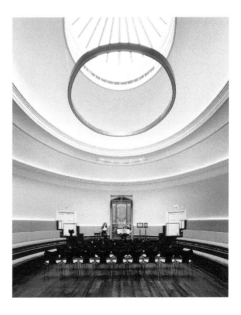

Interior of St Cecilia's Hall. (© Jim Stephenson. Reproduced by kind permission of the University of Edinburgh)

St Giles Cathedral

Also known as the High Kirk of Edinburgh, St Giles – with its distinctive crown-shaped steeple – stands in a prominent position on the High Street and is the principal place of worship of the Church of Scotland in Edinburgh.

According to legend, St Giles had been a seventh-century hermit living in a forest in France with a tame deer at his only companion. The king of the Visigoths shot the deer while out hunting one day, and was impressed by how Giles held it protectively in his arms. The king persuaded him to become the abbot of a monastery. Giles was subsequently canonised, becoming the patron saint of lepers, nursing mothers and the lame, as well as being Edinburgh's patron saint.

A small stone church was founded on this site in 1124, and according to tradition it was burned by an invading English army in 1322 and then rebuilt in a much grander style by wealthy Edinburgh merchants.

During the Middle Ages, Scotland's kings from James I to James V had a close connection with St Giles and attended Roman Catholic Masses there. In 1467 Pope Paul II granted permission for St Giles to become a collegiate church and it remained so until the Reformation, when Scotland became officially Protestant. In 1560 John Knox was elected minister of St Giles and, in keeping with his wishes, Edinburgh Town Council removed all its altars and statues, sold the church plate, reliquaries and other valuables, whitewashed the interior, and introduced seating. It became a cathedral in 1633 when Charles I decided to create a diocese of Edinburgh with St Giles as its cathedral. It still retains this title in recognition of its long history of Christian worship.

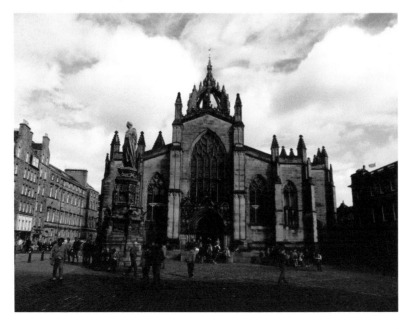

St Giles Cathedral, the High Kirk of Edinburgh.

The Scott Monument

The 200-foot-tall (61-metre) Scott Monument stands in East Princes Street Gardens, looking something like a Victorian Gothic space rocket. Built of sandstone, it is the largest monument to a writer in the world, with a series of viewing platforms reached by a narrow spiral staircase with a total of 287 steps.

Walter Scott was born in Edinburgh in 1771 and studied Classics at the University of Edinburgh, then trained as a lawyer, following in the footsteps of his father. His poetry brought him initial fame, but it was his great historic novels – published anonymously – that earned him a place as a bestselling author.

Following Sir Walter Scott's death from typhus in 1832, a competition was held to design a monument to his memory. This was won by George Meikle Kemp, a joiner, draughtsman and self-taught architect with no architectural qualifications, who entered under a false name. The foundation stone was laid in 1840, and construction was completed in 1844 at a cost of a little over £16,000. Sadly, Kemp never saw the completion of his great design, as he drowned earlier that year in the Union Canal while walking home on a foggy night.

Niches all around the monument hold statues of characters from Scott's novels, and sixteen heads of Scottish writers and poets also appear. Beneath the arch formed by the four columns of the monument sits a white marble statue by John Steell of Sir Walter Scott with his favourite Highland staghound, Maida.

Memorial to Sir Walter Scott, the Scott Monument, Princes Street Gardens.

Scottish Parliament

Before the Treaty of Union of 1707, which united the kingdoms of Scotland and England into Great Britain, Scotland had an independent parliament. However, for the next 300 years, Scotland was governed by the Parliament of Great Britain, subsequently the Parliament of the United Kingdom – both at Westminster.

Following a rise in nationalism throughout the twentieth century, a referendum was held on 1 March 1979, and under the terms of the Scotland Act 1978, an elected assembly would be set up in Edinburgh if at least 40 per cent of the total electorate voted in favour of the proposal. However, despite the vote being 51.6 per cent in favour of a Scottish Assembly, this majority represented only 32.9 per cent of the eligible voting population, so the proposed Assembly could not go ahead.

The 1997 Scottish Devolution Referendum was put to the Scottish electorate in September 1997, and secured a majority in favour of the establishment of a new Scottish Parliament. A Scottish Parliament was founded on 12 May 1999, and on 1 July 1999 power was transferred from Westminster to the new Parliament.

The Parliament had a temporary home in the General Assembly Hall of the Church of Scotland on the Royal Mile, while a new home was being built at Holyrood. Building commenced in June 1999, and the Scottish Parliament building was officially opened by Elizabeth II on 9 October 2004.

The building has been controversial from the outset. It was designed by Spanish Catalan architect Enric Miralles, and was estimated to cost between £10 million and £14 million and due to open in 2001. It finally opened in 2004 with an estimated final cost of £414 million. There was a very mixed public reaction to the design of the building, but it has gone on to win numerous awards.

The controversial architecture of the Scottish Parliament building.

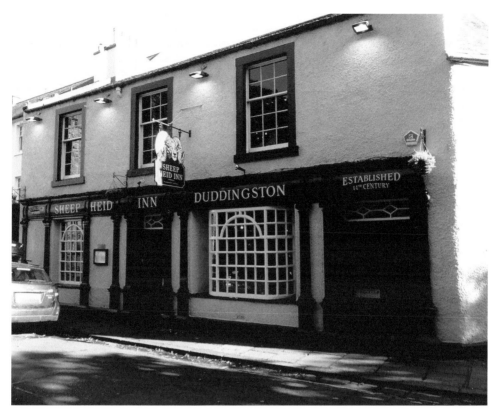

Sheep Heid Inn, Duddingston Village.

Sheep Heid Inn

The Sheep Heid Inn in Duddingston is one of Edinburgh's oldest surviving pubs, with an inn reputed to have been on this site since 1360. It is very close to the twelfth-century Duddingston Kirk, so that claim is quite possibly true.

The name probably comes from the gift of an ornate ram's head snuffbox, which was given to the landlord of the inn by James VI of Scotland in 1580 – a gift from an appreciative 'regular' to the inn. The original snuffbox was sold by an impecunious landlord in the nineteenth century, but a copy remains behind the bar.

Nowadays, the Sheep Heid Inn is a popular bar and restaurant, with a skittle alley dating back to 1870 that is still in use.

Sibbald Walk

At the heart of the 7.5-acre New Waverley development in the Old Town, Sibbald Walk is a new public square off the Canongate and New Street.

Entrance to
Sibbald Walk
from Canongate.

It is named after Sir Robert Sibbald, an eminent physician. Sibbald was born in Edinburgh in 1641, educated at the Royal High School, then the University of Edinburgh. He went on to further studies in Leiden and Paris, and on his return to Scotland he set out to recreate the institutions he had encountered during his time in Europe. He was a botanist, geographer and an antiquarian as well as a physician, and wrote many historical and antiquarian works. He was the first Professor of Medicine at the University of Edinburgh, founder of the Royal College of Physicians of Edinburgh, and was appointed Geographer Royal. Along with Andrew Balfour, he created the physic garden near Holyrood Abbey, which had hundreds of medicinal plants, and which was the forerunner of the Royal Botanic Garden of Edinburgh. He was knighted by Charles II, who also appointed him his personal physician.

Sir Robert Sibbald died in 1722 and is buried in Greyfriars Kirkyard.

James Young Simpson

Born in Bathgate, near Edinburgh, in 1811, James Young Simpson is best remembered for pioneering the use of chloroform as an anaesthetic, especially in childbirth.

Born into a family of village bakers, Simpson showed great academic promise at school, and his family were committed to being able to finance him through further education. He initially entered the University of Edinburgh at the age of fourteen as an arts student and then began medicine two years later, graduating from the Medical School in 1832. Simpson's speciality was obstetrics and he went on to become Professor of Medicine and Midwifery at the University of Edinburgh at the young age of twenty-eight.

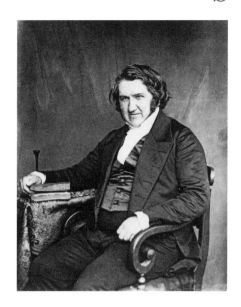

Sir James Young Simpson. (Photograph by James Good Tunny. © National Galleries of Scotland)

Simpson was keen to find a new, safe anaesthetic, and he and his assistants experimented on themselves with various new chemicals until they came across chloroform. Simpson used this for the first time in obstetrics in 1847 and it quickly became the anaesthetic of choice for general surgery, although not initially for obstetrics. In 1847 he was appointed physician to the queen in Scotland, and was elected president of the Royal College of Physicians of Edinburgh in 1850. In 1853 Queen Victoria's eighth child, Leopold, was born with the use of chloroform, and Simpson subsequently became much feted in medical circles. James Young Simpson was the first person to be knighted for services to medicine in 1866.

In 1879, using funds collected to commemorate Sir James Young Simpson's contribution to obstetrics, a purpose-built maternity hospital was opened in Edinburgh to provide a facility where the poor could access medical supervision for childbirth.

In 1939, the new Simpson Memorial Maternity Pavilion opened at Lauriston Place, next to the main Royal Infirmary of Edinburgh. When the Royal Infirmary moved to a new site at Little France in the early 2000s, James Young Simpson was commemorated again in the Simpson Centre for Reproductive Health.

James Young Simpson died in May 1870 at his home in Queen Street, Edinburgh. A grave was offered in Westminster, but the family declined, and he was buried in Edinburgh's Warriston Cemetery.

Robert Louis Stevenson

Robert Lewis Balfour Stevenson, famous for writing *Treasure Island*, *Kidnapped*, and *The Strange Case of Dr Jekyll and Mr Hyde*, among many others, was born in

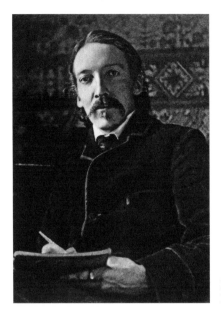

Robert Louis Stevenson. (Photograph by Maclure, Macdonald & Co. © National Galleries of Scotland)

Edinburgh in 1850 into the Stevenson family of engineers, who had built many of the lighthouses around the coast of Scotland. Robert was often ill as a child and missed a lot of his schooling. He was, however, able to go to the University of Edinburgh to study engineering, to please his father, but abandoned this course and studied law instead. Although he did graduate, he never practised law and by this time he had decided he wanted to be a writer. He changed the spelling of his name from 'Lewis' to 'Louis' and dropped 'Balfour' from his name.

As well as writing fiction, Robert was a travel writer and spent much of his life travelling. In 1889 he finally decided to settle with his family, in Samoa, where he died in 1894 of a cerebral haemorrhage.

Robert Louis Stevenson is associated with several places in Edinburgh including Howard Place (where he was born), Inverleith Terrace and Heriot Row (where his family later moved to), Colinton (where his grandfather was a minister), and Swanston (where he spent several summers with his family). A housing estate in the Clermiston area of Edinburgh commemorates *Kidnapped* in its street names, which include Alan Breck Gardens, Balfron Loan and Ransome Gardens.

Surgeons' Hall

The Surgeons' Hall is the headquarters of the Royal College of Surgeons of Edinburgh. It was designed by William Henry Playfair and dates to 1832. It is a beautiful neoclassical building, with features including oak-panelled rooms and tiled fireplaces. The Royal College of Surgeons was incorporated in 1505 as the Barber Surgeons of Edinburgh, making it the oldest of the surgical Royal Colleges in the United Kingdom.

The Surgeons' Hall Museums date from 1699, when the Incorporation of Edinburgh Surgeons advertised publically for donations of 'natural and artificial curiosities'. By the early nineteenth century the Incorporation had received a royal charter to become the Royal College of Surgeons of Edinburgh.

The modern campus includes office space, postgraduate accommodation, museums, library, function and meeting space, a hotel, and a café. The museums, which comprise the Dental Collection, The History of Surgery Museum and the Wohl Pathology Museum, were reopened in 2015 after a major refurbishment programme. The complex has taken in adjacent buildings in recent years, and surrounds beautiful gardens. It is a very popular venue for meetings and events, and during August it becomes a busy Fringe venue.

The façade of Surgeons' Hall, Nicolson Street.

Trams

If you mention trams to an Edinburgh citizen you're likely to either get a response about what a waste of money the new trams are, or a nostalgic rose-tinted reminiscence about how great the old trams were.

Edinburgh trams started out with the horse-drawn variety in 1871, with the last journey taking place in 1907. From 1888 cable-driven trams were operating, and last ran in 1923. Electric trams had been running in Leith (a separate burgh at the time)

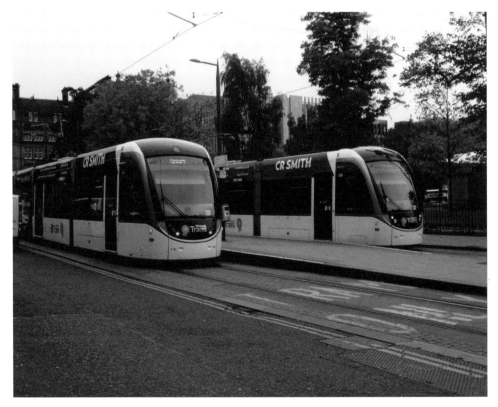

Two trams pass each other in St Andrew Square.

since 1905 but weren't introduced into Edinburgh until the early 1920s. Until then, passengers wanting to travel the full length of Leith Walk had to change from one type of tram to the other at Pilrig, the boundary between Leith and Edinburgh. By the 1950s trams were going out of fashion and motor buses were much more popular. The last Edinburgh tram ran on 16 November 1956.

In 2001 a proposal was put forward for a new tram network. This would comprise of three routes, all of which would pass through the city centre. Construction began in 2008 but the scheme met with many delays and cancellations, including contractual and political disputes and funding problems, and the scheme was eventually cut back to a single line running from Edinburgh Airport to York Place in the city centre.

The new tram line opened on 31 May 2014 at a cost of £776 million – more than double the original estimate. At the time of writing, an extension to Newhaven is under consideration.

Tron Kirk

Christ's Church at the Tron, as it was originally known, was built between 1636 and 1647 to a design by John Mylne, royal master mason, at the order of Charles I when he named Edinburgh a city. The name comes from the ancient 'weighbeam' – the Tron – which stood nearby. The Tron itself was used as a place of punishment, as this extract from the diary of John Nicoll reports:

> 10 November 1658. Thair wes ane yong boy callit Bynning brocht to the Trone of Edinburgh, and his lug boirot and naillit thereto: quhairat he stuid the space of four houris, and thaireafter stigmatised in his face with ane het yrne, berand the letter F, for counterfying of wrytes.

There have been several changes to the building over the years. It was substantially altered in 1785 when side aisles were removed to reduce the width to enable South Bridge and Blair Street to be created. In 1824 the spire was destroyed in the Great Fire of Edinburgh, and was replaced with a different design complete with turret clock in 1828.

The building was closed as a church in 1952, acquired by the city, subsequently left to decay, and the interior was eventually gutted.

During excavation work, an exciting discovery was made when the foundations of sixteenth-century buildings in the long-vanished Marlin's Wynd were uncovered. These were glassed over, and visitors could view them when the building was briefly used as a tourist information centre in the 2000s. The floor appears to have now been covered up again, and the building is presently being used as a market.

The spire of Tron Kirk.

University of Edinburgh

Following a bequest by Bishop Robert Reid in his will of 1558 to found a college of higher learning in Edinburgh, the town council became determined to establish a university. They originally hoped monastic sites might revert to them and be used for educational purposes, but little progress was made with this, and plans were eventually revived in the late 1570s. The town was finally able to acquire Kirk O'Field in 1581.

Originally known as the Tounis College, its principal building was Hamilton House, which was refurbished to provide classrooms, a college hall and seventeen sleeping chambers for students, with the intention that all students should reside within the college walls. However, even in the early days, there wasn't sufficient space for them all.

Old College quad, University of Edinburgh. (© Paul Dodds. Reproduced by kind permission of the University of Edinburgh)

The first regent, with responsibility for all teaching and administrative duties, was appointed on 14 September 1583, and the college officially opened on 14 October 1583, with one additional tutor and with an attendance of between eighty and ninety students. It was the fourth university to be founded in Scotland, at a time when England only had two.

By the 1760s, a new main building was desperately needed, and the foundation stone of its first custom-built premises, Old College, was laid on 16 November 1789. It was hoped that funds could be raised by subscription, but the town council was forced to turn to the government for money. However, due to the outbreak of war with France, funds were more urgently needed elsewhere and building work was suspended in 1794, only resuming in 1815.

The university continued to expand over the years, adding buildings and new campuses, as well as new faculties, and has a growing list of famous alumni. The university has many historic buildings throughout the city, including St Cecilia's Hall, Scotland's oldest purpose-built concert hall, and Teviot Row House, the oldest purpose-built student union building in the world. The College of Medicine and Veterinary Medicine has long been regarded as one of the best in the world, with its students and alumni over the years having made many significant and life-changing inventions and discoveries.

The University of Edinburgh has a current roll of approximately 40,000 students and employs over 13,000 staff, and is one of the world's leading research universities.

Usher Hall

The Usher Hall, on Lothian Road, is a concert hall which opened in 1914. Whisky magnate Andrew Usher donated £100,000 to the city in 1896 to fund a new concert hall. It took a while to find a suitable site, but space for the Usher Hall was eventually found in 1910 when the Board School on Lothian Road shut its doors. The school building was quickly demolished and the new hall could finally become a reality. An architectural competition was launched in 1910, which attracted over 130 entries. The winning design had a return to classical features, perhaps as a backlash against elaborate Victorian Gothic style. George V and Queen Mary laid two memorial stones in July 1911, and the hall was officially opened on 16 March 1914. Andrew Usher, sadly, never saw the hall as he died before building work commenced.

The curved walls, unusual for the time, were made possible by developments in reinforced concrete, and interior decorative plaster panels show figures from world music as well as famous Scots. When it opened, *The Scotsman* reported: 'It is not too much to say that those present, who saw the hall for the first time, were greatly struck with its dignified proportions, its open and airy aspect, and the character of its decorative detail.'

Usher Hall, Lothian Road.

The organ, built in 1913 at a cost of around £4,000, was designed to be the focal point of the hall, both visually and musically. The organ was completely restored in the early 2000s. In 2010 a new glass-fronted wing was added that houses a new café/bar, a bigger and better box-office area, topped by new hospitality spaces and extended office accommodation.

The Usher Hall continues to be owned and run by the City of Edinburgh Council.

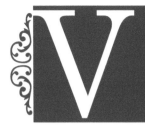

The Vennel

The Vennel is a picturesque narrow street leading from Lauriston Place to West Port, which takes its name from the old French word *venelle*, meaning 'a small street or public passage'. It starts off at Lauriston Place down the side of the grounds of Heriot's School as a roadway, then becomes a footpath, heading down a steep flight of steps to the Grassmarket.

The Vennel contains one of the remaining parts of the Flodden Wall, and gives a view of Edinburgh Castle from the steps.

The Vennel – a picturesque route to the Grassmarket.

Victoria Street and Victoria Terrace

The gently curving Victoria Street with its setted road and brightly painted shopfronts leads from the Grassmarket to George IV Bridge, and is probably one of the most photographed streets in Edinburgh.

Victoria Street was built between 1829 and 1834 as part of a series of improvements to the Old Town and replaced the precipitous street called the West Bow, which was previously the only access from the Grassmarket to the Lawnmarket. The new street was initially called Bow Street, but the name was changed in 1837 when the young Queen Victoria came to the throne.

A terrace was built on the north side with a series of arches underneath, which were later filled with shops. A few of the earlier buildings remain at the foot of Victoria Street.

Colourful shopfronts of Victoria Street with Victoria Terrace above.

Water of Leith

Unlike many capital cities – London on the Thames, or Paris on the Seine, for example – Edinburgh was not built around a great river, but we do have the Water of Leith. The Water of Leith winds its way through Edinburgh for 24 miles (35 kilometres) from the Pentland Hills to the Port of Leith, with a walkway along over 12 miles of its length. At one time the water powered waterwheels for over seventy mills along its way, producing paper, fabric, flour and snuff. The Water of Leith was crucial in the development of Edinburgh as an industrial city, but of course the river became hugely polluted.

After the mills closed, the river was slowly able to recover and is now home to a wide range of wildlife and plant life, and is looked after by the Water of Leith Conservation Trust. The walkway passes through some lovely parts of the city, including Colinton Dell and the Dean Village, and is suitable for cycling as well as walking.

Much of the work to keep the Water of Leith and its environs clean and well maintained is done by volunteers, and there is an educational programme run by the Trust, who are based at the Visitor Centre at Slateford.

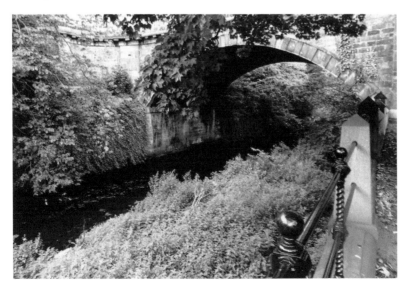

Water of Leith
at Stockbridge.

The Witches Well

The witches well, a cast-iron wall fountain dating from 1894, is situated at the entrance to the Castle Esplanade and commemorates the site where over 300 women were burned at the stake over a period of 250 years, accused of being witches. Those killed were often mere herbalists, the mentally ill, or those on the wrong end of someone else's ill will.

An entry in the diary of John Nicoll, a lawyer and prolific diary writer, reports among several such incidents: 'Upone the 14 of October 1657, thair wes ane woman brint on the Castelhill of Edinburgh for witchcraft'.

The wording on the plaque reads:

> This fountain, designed by John Duncan, R.S.A. is near the site on which many witches were burned at the stake. The wicked head and serene head signify that some used their exceptional knowledge for evil purposes while others were misunderstood and wished their kind nothing but good. The serpent has the dual significance of evil and wisdom. The foxglove spray further emphasises the dual purpose of many common objects.

Alleged witches were often tortured before being put to death. One common example was by 'douking' in the Nor' Loch. If they drowned, they were deemed to have been innocent; if they floated, then they were deemed to be a witch and condemned to be burnt to death.

The last Scottish woman to face trial for witchcraft was jailed for her crime as recently as 1944.

The Witches Well, Castle Esplanade.

X

Xmas

Christmas in Edinburgh is a huge occasion now, which attracts hundreds of thousands of visitors each year from all over the world. 'Edinburgh's Christmas', currently produced by live entertainment company Underbelly, is a six-week celebration that runs from November through to early January, and includes such attractions as an outdoor ice skating rink, a Christmas market, theatre and live music, and of course Santa's Grotto. Apart from these public celebrations, Christmas is also of course traditionally a time for spending with friends and family, giving presents, having special meals. But how traditional is it? Looking at all this, it's hard to believe that, within living memory, Christmas wasn't even a public holiday.

Christmas Day only became a public holiday in Scotland in 1958, and into the 1960s many people still worked on Christmas Day if it was a weekday. It wasn't until 1974 that Boxing Day also became a public holiday. Up until that time, Hogmanay (New Year's Eve) was by far the biggest celebration.

Until the Reformation in 1560, Christmas in Scotland was a religious feasting day. The Kirk disapproved of its celebration because of a perceived association with the Roman Catholic Church.

Christmas in Scotland had been banned in 1640 by an Act of Parliament, which was repealed in 1686. Despite this, however, the Presbyterian Church of Scotland continued to discourage Yule celebrations as they felt it didn't reflect what was in the Bible, and those Scots who wanted to celebrate had to do so quietly and secretly. So, for nearly 400 years, Christmas – now the biggest celebration of the year – was not officially a holiday in Scotland.

Christmas in Princes Street.
(© Digital Triangle Creative Ltd)

Y

Younger's Brewery

William Younger & Co., commonly known as Younger's, was a brewery founded by William Younger and established in Leith in 1749. After William's death, his son Archibald established his own brewery in 1778 within the precincts of Holyrood Abbey, a good business move as ale brewed within the abbey sanctuary escaped the duty of 2 pennies Scots, which was levied by the town council on every pint brewed within the town walls. In 1786 he acquired bigger premises, and in 1803 even larger premises at North Back Canongate (now Calton Road).

Archibald's brother, also William Younger, had started his own brewhouse in 1796 within the abbey precincts, and then moved to nearby Horse Wynd. After Archibald died in 1819, William sold Archibald's brewery and expanded his own by buying more property in Horse Wynd. Along with neighbouring property bought in 1829, this was the site that would become the Abbey Brewery. This whole area was ideal for brewing, because of the clear spring water there.

The business continued to expand, and by the beginning of the twentieth century it was reckoned that one quarter of all Scotland's beer was produced by Younger's. Younger's sales slogan was 'Get Younger Every Day'. Abbey Brewery was a major employer in the Canongate area, and many a local family had all of their members working there.

Younger's merged with William McEwan & Co. in 1931 to form Scottish Brewers Ltd, which in turn merged with Newcastle Breweries in 1960 to form Scottish & Newcastle. The Scottish Parliament now stands on the site of Abbey Brewery.

Zeppelin Air Raid

Edinburgh, and more particularly Leith, faced several Zeppelin bombing raids on the night of 2–3 April 1916, in the first ever aerial attack on the city. Apparently the Germans' mission had been to attack the naval base at Rosyth in Fife, and to then destroy the Forth Bridge. Instead, however, they targeted Leith Docks where a large number of ships were fully lit and visible from afar.

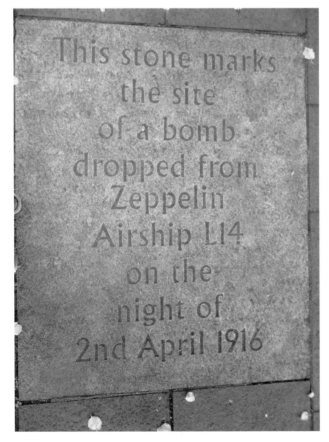

Marking the site where a bomb was dropped in a Zeppelin air raid in the Grassmarket.

Leith Docks were something of an obvious target, and there was considerable damage to boats, a grain warehouse, a whisky bond and several other buildings in the docks area. There were some lucky escapes, where incendiary bombs fell on roofs and went straight through the top floor rooms into rooms below before exploding, but with no one being injured. There was sadly loss of life in Commercial Street, where a man was killed as he lay in bed, and in Bonnington Road where an infant was killed. One person was killed outside the White Hart Hotel in the Grassmarket. Six men taking refuge in a doorway lost their lives in Marshall Street, in the Southside area. In all, thirteen fatalities and twenty-four injured were reported.

One bomb also fell close to Edinburgh Castle, prompting the Secretary of State for Scotland to arrange the removal of the Regalia of Scotland from the Crown Room for safekeeping in a castle vault.

A plaque on Edinburgh Castle rock marks the bombing, as does a paving stone in the Grassmarket.

Zoo

The Royal Zoological Society of Scotland was founded in 1909 by Thomas Gillespie, an Edinburgh lawyer, visionary and nature enthusiast. It took him four years to get enough support and funding to enable the society to buy an eighty-five acre site on the slopes of Corstorphine Hill for £17,000 with help from the City Council.

Edinburgh Zoo opened to the public on 22 July 1913 and was incorporated by royal charter that same year. In the charter, its main objective was: 'To promote, facilitate and encourage the study of zoology and kindred subjects and to foster and develop among the people with an interest in and knowledge of animal life.' The RZSS (who also operate the Highland Wildlife Park) continues this objective with its work in education and conservation, and also supports a wide range of research and conservation projects worldwide.

The main attractions at Edinburgh Zoo include Europe's largest outdoor penguin pool, which has colonies of king, gentoo and rockhopper penguins, with a daily Penguin Parade. Many years ago, when there was a lot less traffic, the penguins used to be allowed to walk out into Corstorphine Road but now they are sensibly restricted to inside the zoo grounds. The zoo is also home to the United Kingdom's only koalas and giant pandas.

Edinburgh Zoo has an extensive educational programme for both schools and the general public, or, of course, you can simply have a day out and enjoy seeing the animals.

Acknowledgements

The author and publisher would like to thank the following organisations for permission to use copyright material in this book: Camera Obscura and World of Illusions, Flow Communications, Historic Environment Scotland, National Galleries of Scotland, National Museum of Scotland, National Trust for Scotland, StonehillSalt PR Ltd, Underbelly and University of Edinburgh.

In Edinburgh, we have the great fortune to have Central Library with its excellent collection of books on Edinburgh and Scotland, which is a wonderful resource for research, so thank you to the City of Edinburgh Council Libraries Department.

Last, but never least, a huge thank you to my husband, Tom King, for his never-ending support and encouragement.

Bibliography

The following books have been invaluable resources:

Book of the Old Edinburgh Club (Edinburgh: The Old Edinburgh Club, various dates).

Chambers, Robert, *Traditions of Edinburgh* (Edinburgh: W & R Chambers Ltd, 1825, revised 1868).

Grant, James, *Cassell's Old and New Edinburgh* (London: Cassell, Petter, Galpin & Co., 1880).

Harris, Stuart, *The Place Names of Edinburgh* (Edinburgh: GordonWright Publishing, 1996).

About the Author

Lisa Sibbald has lived in Edinburgh her entire life and has always had a great love for the city and its history. She is a reviewer of books, theatre, music, ballet and opera and also writes articles and features. Lisa has spent most of her working life in secretarial and administrative jobs (extremely useful for a writer!), and is very much involved with her local community. *A-Z of Edinburgh* is her first book.

www.lisasibbald.weebly.com